LIGHT YEARS

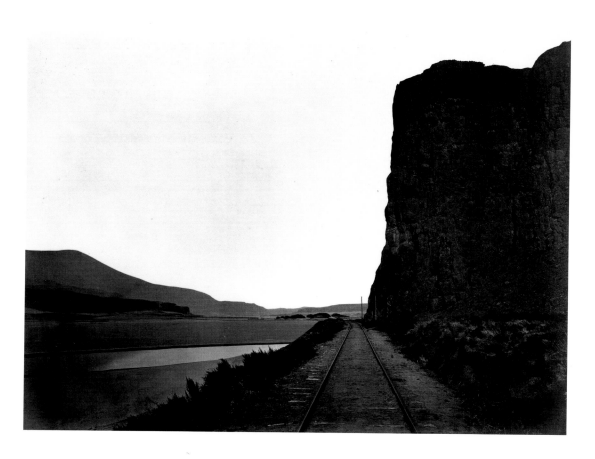

Carleton E. Watkins. *Cape Horn near Celilo*, 1867.

LIGHT YEARS

The Friends of Photography 1967–1987

EDITED BY JAMES G. ALINDER

Untitled 43 THE FRIENDS OF PHOTOGRAPHY CARMEL, CALIFORNIA

ACKNOWLEDGEMENTS

Introduced some one hundred and fifty years ago, photography is a relatively young creative medium, and while the twenty years since the founding of The Friends of Photography is not a long time, the past two decades have been so fulfilling and the growth of the organization so great that I think this anniversary is an appropriate time to assess the evolution of our organization since 1967. In addition, since we are poised on the brink of a major transition that will move our operations to San Francisco, the time is right to reflect on what contributions The Friends has made during its years in Carmel.

The present issue of *Untitled*, the forty-third in the series and the thirtieth for which I have had responsibility, reviews the past two decades' activities of The Friends. In addition to a selection of images representing the range of photographic interests of the organization and the essays by Beaumont Newhall, Peter C. Bunnell and myself, the book contains a comprehensive listing of the specific programs of The Friends, and of the individuals who have been a part of the organization's history.

As in any book of this nature, there are many individuals who have played a part in bringing it into being. Thanks go to Beaumont Newhall and Peter C. Bunnell for taking time from their many other responsibilities to contribute essays to the book. Thanks also to David Featherstone for his editorial expertise in shaping the volume. In addition, thanks must go to Linda Bellon-Fisher for her editorial assistance and for her help in securing reproduction rights, as well as to Lorraine Nardone, Sylvia Wolf and John Breeden for compiling, organizing and cross-checking information contained in The Record. Grateful acknowledgement must also be given to Wilsted & Taylor in Oakland, California, for assisting with the design of the book, setting the text into type and producing the mechanicals. David G. Gardner and the staff of Gardner Lithograph in Buena Park, California, have again achieved the quality printing that we have come to expect of them. Thanks must also go to all of the trustees, staff, artists and others, with apologies to any who may have been inadvertently left out of the historical record, whose contributions have made this twentieth anniversary of The Friends of Photography an event to celebrate.

James G. Alinder, *Editor*
THE UNTITLED SERIES

Untitled 43. This is the forty-third in a series of publications on serious photography
by The Friends of Photography. Some previous issues are still available.
For a list of these write to Post Office Box 500, Carmel, California 93921.

Front cover: Ansel Adams, *Aspens, Northern New Mexico*, 1958

Except as listed below, permission to reproduce the photographs included in this volume has been secured from the artists, who have retained copyright in their work. Acknowledgement is also given to the following: The Ansel Adams Publishing Rights Trust (front cover, page 11); The Art Museum, Princeton University (page 15); the Center for Creative Photography and the Trustees of the University of Arizona (page 17); Susan Harder (page 52); the Imogen Cunningham Trust (page 12); Harry Lunn (page 56); the Oakland Museum (page 16); Pace/MacGill Gallery (page 31); Aperture Foundation Inc., Paul Strand Archive, © 1971 (page 21); the Trustees of the Max Yavno Estate (page 43).

Contents

The Beginnings BEAUMONT NEWHALL

On January 1, 1967, a meeting was called at Ansel and Virginia Adams' home to discuss the possibility of establishing a photography gallery in two rooms of the Sunset Center, a former school in Carmel that functioned as a civic cultural center and was managed by Cole Weston.

Besides Ansel and Virginia Adams and Nancy Newhall and myself, the group included Morley Baer, Edgar Bissantz, Art Connell, Liliane DeCock, Rosario Mazzeo, Gerry Sharpe, Brett Weston and Gerald Robinson, who was visiting from Portland, Oregon. This group showed great enthusiasm over the possible opening of a gallery and the establishment of a society, which we named The Friends of Photography. Ansel Adams was elected president that very day; Brett Weston, vice president; Rosario Mazzeo, secretary; and Art Connell, treasurer. The next day, Ansel, Rosario and I went with Cole to inspect the area available for the gallery at Sunset Center. We approved it, and the stage was set for the development of an organization on the West Coast that would serve the needs of creative photography.

Nancy Newhall wrote of the specific need for such a society in her introduction to The Friends' first publication, *Portfolio I: The Persistence of Beauty.*

> [At one time] the excitement focused in New York, and photographers made pilgrimages there, especially to Stieglitz and the galleries in which he was showing live art. Then at the Museum of Modern Art and, later, the George Eastman House, the same excitement, the same sense of battle and enrichment arose, and from these centers, publications and circulating exhibitions went forth to feed schools and students everywhere. But, strangely, no such center had yet developed on the West Coast, though it had produced towering and magnetic figures in photography, and one of them, Ansel Adams, had made repeated attempts to end the isolation in which the West Coast found itself by bringing in other creators and their work.

> Then, on New Year's Day 1967, a dozen or so of us met at Adams' house. Such a group might easily have become merely local, devoted to showing the work of the extraordinary constellation of photographers who live nearby. Instead, we decided to found a society, national and even international in scope, whose purpose should serve as the long-dreamed-of center, bringing in outstanding talent from everywhere, initiating exhibitions, holding

Ansel Adams and Imogen Cunningham Awarding Jerry Uelsmann the Title of Honorary West Coast Photographer at Weston Beach, Point Lobos, 1969. This photograph by Ted Orland was made at an early workshop.

workshops and programs of lectures and films, and publishing, in various forms, monographs on individual photographers and works of interpretation, enlightened criticism and history. The membership should include not only practicing photographers but musicians, poets, painters, sculptors, critics, collectors, art historians, museum directors and others who are deeply interested. And so we called ourselves The Friends of Photography.

It is remarkable that the hopes of the enthusiastic founders of The Friends have, over the last twenty years, been realized even beyond their dreams. The long and impressive compilation of exhibitions, publications, workshops and other accomplishments that is included as a part of this special issue of *Untitled* stands as a great tribute to the hard work of the staff and trustees who have raised The Friends of Photography from a handful of enthusiasts to the 15,000 members it has today.

The First Exhibition JUNE 23–JULY 30, 1967

 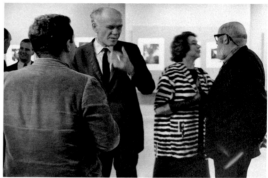

 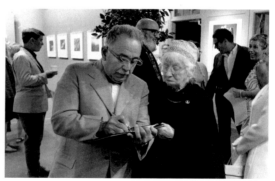

The reception for the initial exhibition in The Friends of Photography Gallery was attended by many of those who had helped to create the organization. *Upper left:* Ansel Adams talks with Wynn Bullock. *Upper right:* Beaumont Newhall converses with a gallery visitor while Nancy Newhall and Adams visit. *Lower left:* Neil, Cole and Brett Weston in front of their father's photographs. *Lower right:* Board of Trustees secretary Rosario Mazzeo interviews Imogen Cunningham. Photographs by Peter Stackpole.

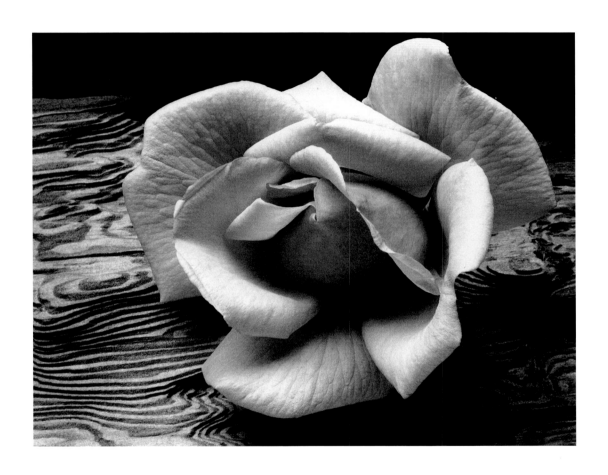

Ansel Adams. *Rose and Driftwood, San Francisco, California*, c. 1932.

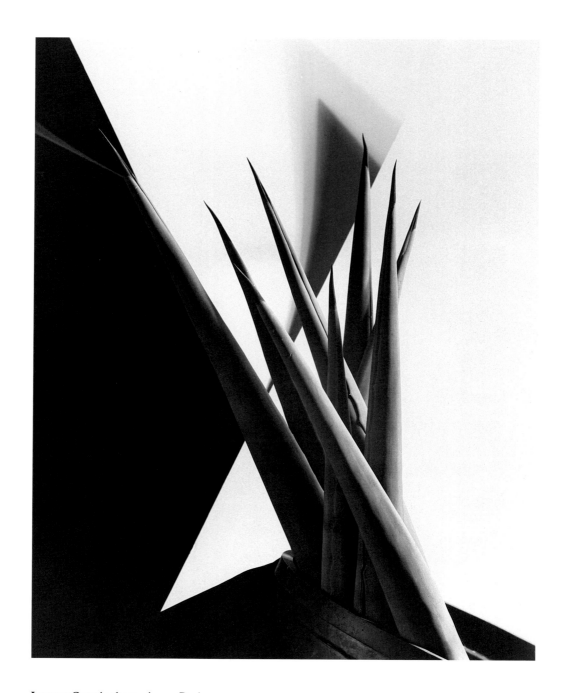

Imogen Cunningham. *Agave Design 1*, 1920s.

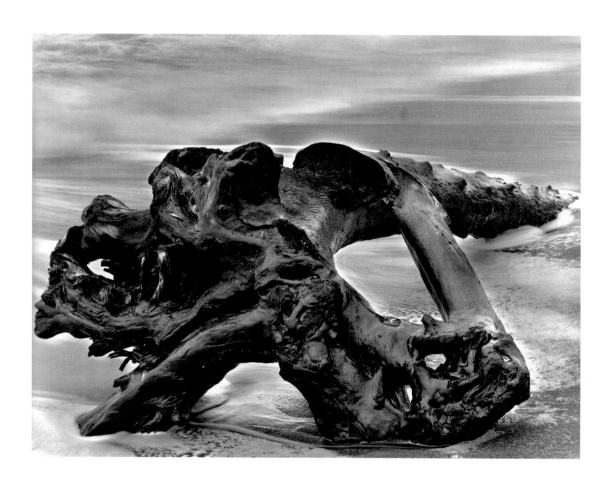

Wynn Bullock. *Driftwood*, 1951.

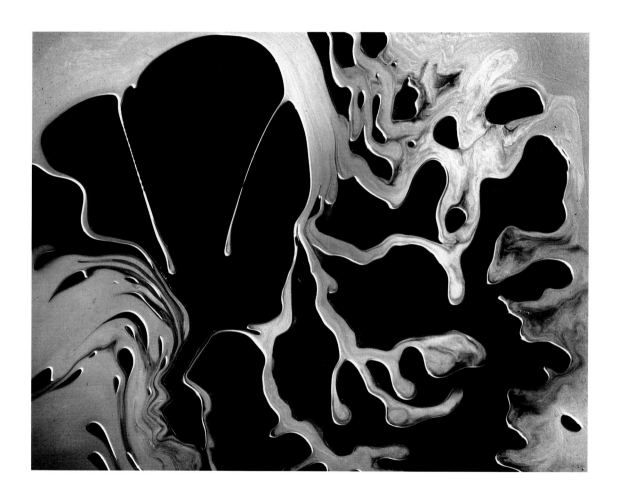

Brett Weston. *Broken Glass*, 1955.

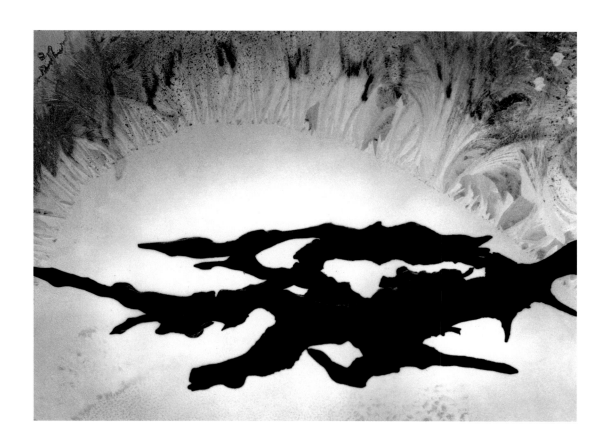

Minor White. *Root and Frost, Rochester, New York*, 1958.

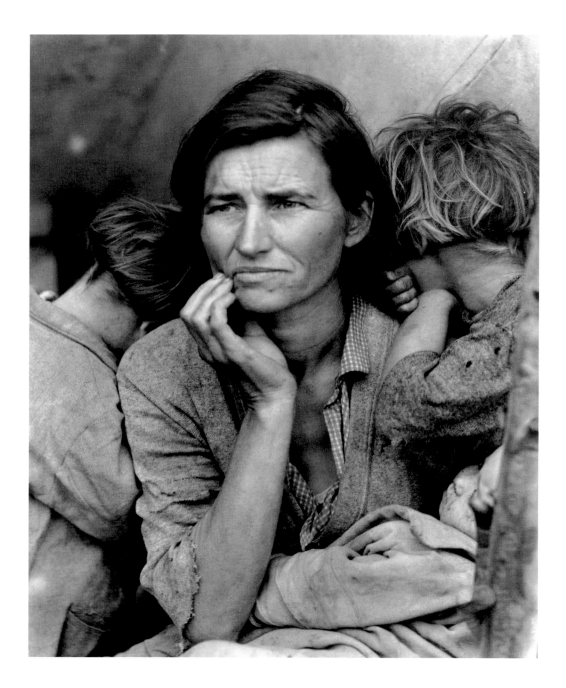

Dorothea Lange. *Migrant Mother, Nipomo, California*, 1936.

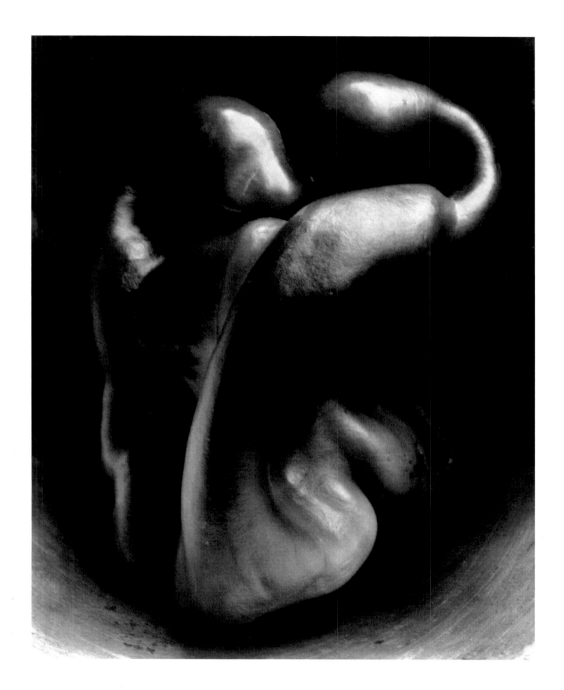

Edward Weston. *Pepper #30*, 1930.

Why The Friends? PETER C. BUNNELL

To look back on the development of an organization after twenty years is, in certain respects, an intimidating experience. We may feel, on one hand, that specific goals have not been met; yet, on the other hand, we can look with collegial pleasure on the remarkable advances that have been made. Some accomplishments go beyond their original expectations; and, in hindsight, some may even be seen to have been inspired. In the case of The Friends of Photography, as is amply illustrated in this anniversary publication, reflecting on twenty years of history is a wholly satisfying experience. I will not dwell on the establishment of The Friends or on the creation of its first goals, since Beaumont Newhall, one of the founders, touches on these matters in his introduction to this book. Nor will I enumerate the evolving successes, for these are covered in James Alinder's historical essay and in the chronological program histories that are also contained herein. Rather, I will identify briefly my feelings about The Friends as we stand poised to enter our third decade.

The basic construct of The Friends of Photography owes its origin to the vision of Ansel Adams, who was our founding leader as well as our guiding spirit during the last years of his life. Fundamentally, The Friends is an organization whose purpose is to support expressive photography everywhere and for all time. Its mission is to be a living, diverse and evolving educational force that will encourage people to renew, heighten and energize themselves through the experience of fine photography. The intent of The Friends' programing has been, and will continue to be, to enlarge public interest and to expand audience expectations through the coherent and sympathetic presentation of photography of every persuasion and by every generation. Most importantly, The Friends serves as a stimulus to encourage people to look ahead once they have felt the touchstone of works by artists of the past and present.

At the memorial service that was held for Ansel Adams in 1984, I said, "The title of our organization is characteristic of the intelligence of Ansel. In his youth, in 1932, he eagerly aligned himself with the audacious notion that Group *f*/64 represented—that there was an orthodoxy to photography—but with maturity, a graciousness ripened and a certain pluralism triumphed in his understanding, so that in his naming of The Friends we have an expression of community, of originality and diversity." These primary concepts continue to be our guiding tenets.

Board chairman Ansel Adams and president Peter C. Bunnell confer at one of the annual meetings of the Board of Trustees.

In this era of seemingly infinite confrontation, it is critical that there be a focus for a sense of sharing in photography, some structure that inspires those who seek to affirm the nobler, more expansive fulfillment of man's creative potential. It is under this banner, strengthened even by the proposition that photography as we know it today is unlikely to be the basis for the medium in 1997, that The Friends of Photography begins its third decade. The core or essential idea will nonetheless remain the same--the ability of one person, working from within the self, to achieve communication with his fellow man. The support of such endeavors falls on relatively few; but the audience is vast, and it has been their right to expect continued and discriminating guidance in their search for meaning and values. This is why there must be a Friends of Photography, why there will be a Friends of Photography and why it will be an ever stronger Friends of Photography in the decades ahead.

One of the central precepts in photography, and one the artist understands fully, is that of responsibility. It is part of assuming an expressive position in public, of believing one has something to say about knowledge and about life itself. In the fullest expression of the artist's statement, we may find the ultimate testimony of the reward to be gained by sharing. To encourage and make accessible the ideal embodied in the finest works of art requires a similar sense of responsibility in sponsorship and presentation. We at The Friends have accepted this trust and summons. We believe in our mission of giving and enhancing. This act places a heavy burden on the staff and trustees, but it is one that I believe we all readily embrace and try to carry out with dignity. Where The Friends of Photography is located, or what its physical plant may be, are only the outward manifestations of our real mission. In paging back over twenty years of service, we can look with pride on certain achievements, but only in the spirit of a challenge accepted, a trust repaid and a conviction to render all we possibly can to give meaning to the future. Art can make a difference, not only for artists but for others; and this, in short, is the primary reason why there is a Friends of Photography.

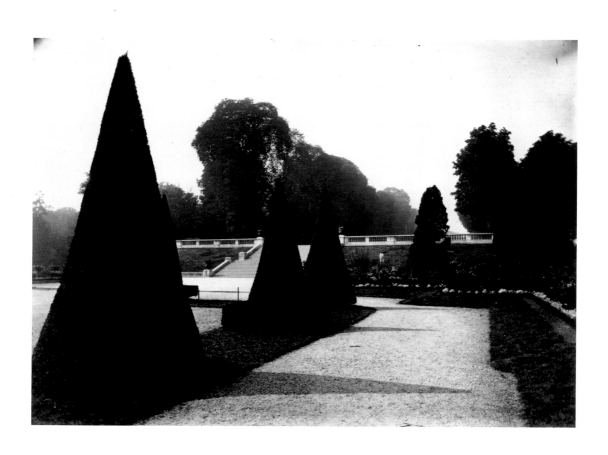

Eugene Atget. *Saint-Cloud*, 1921–1922.

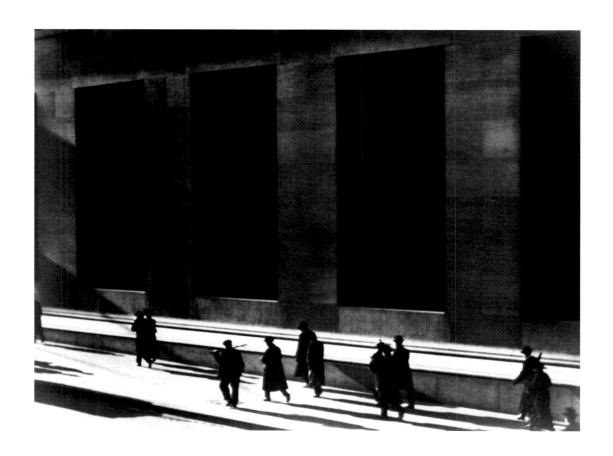

Paul Strand. *Wall Street, New York*, 1915.

Paul Caponigro. *Brewster, New York*, 1963.

William Garnett. *Sand Dune #1, Death Valley, California*, 1954.

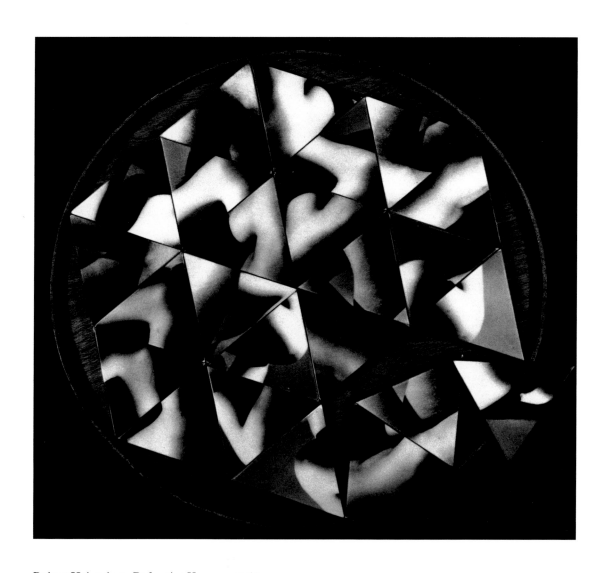

Robert Heinecken. *Refractive Hexagon*, 1965.

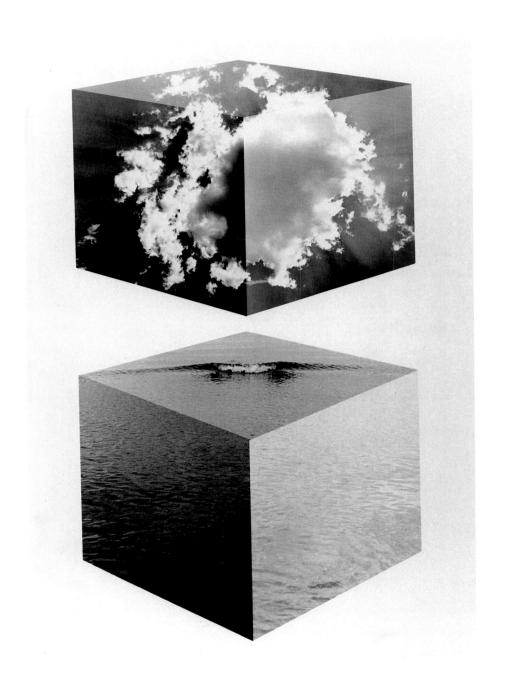

Jerry Uelsmann. *Ocean and Cloud Box*, 1980.

Harry Callahan. *Chicago*, 1950.

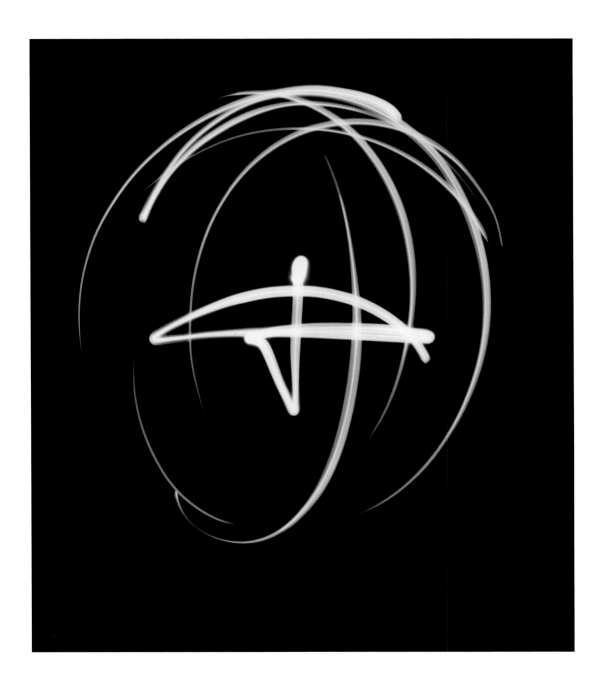

Barbara Morgan. *Samadhi*, 1940.

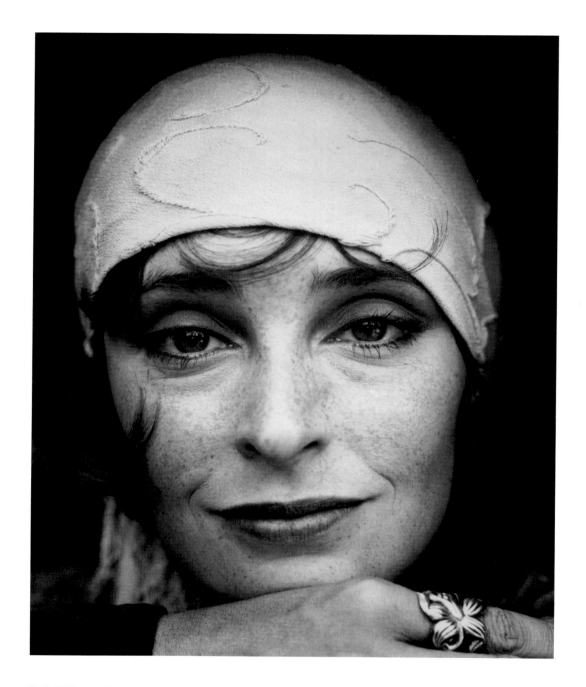

Jack Welpott. *Kathleen Kelly*, 1972

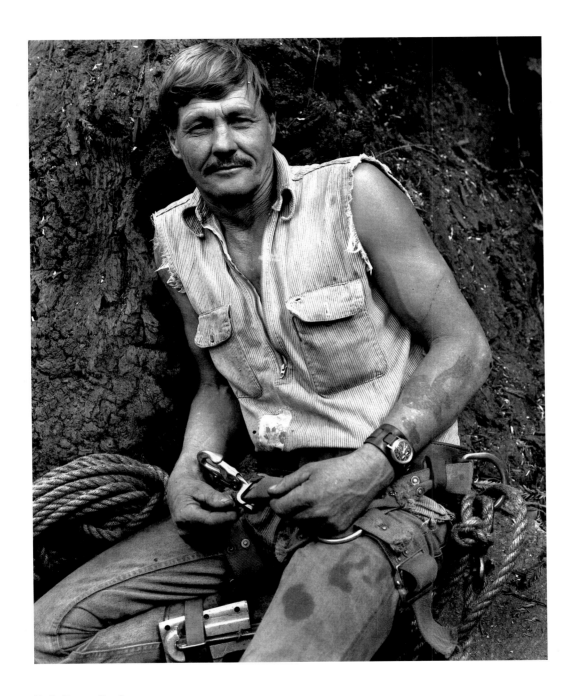

Judy Dater. *Sandy*, 1975.

Ralph Gibson. *Untitled, from Syntax,* 1983.

Robert Frank. *Political Rally, Chicago*, 1955–1956.

The Friends: A Retrospective View JAMES G. ALINDER

PRECISELY midway through the twenty-year history that we celebrate in this *Untitled*, I became the executive director of The Friends of Photography. While I was an early member of the organization, most of my knowledge of the first decade of The Friends has been gleaned from the writings and reminiscences of those who participated in its administration and programs. By contrast, I have lived the second decade of The Friends.

This retrospective can only touch on the highlights. A comprehensive view is contained in *The Record*, a compilation of the people, programs and events of the past twenty years that makes up the final twenty-four pages of this book. While a few specific references will be mentioned here, *The Record* lists all of those individuals who have been important to this organization.

The significance of the invention of photography, almost one hundred and fifty years ago, could hardly have been realized in 1839. In the last forty years, our society has become increasingly media oriented, and photography has emerged as one of the dominant arts of our times. Through its use in journalism, communications, science and technology, photography has had a tremendous impact on our society, and few individuals can avoid having daily contact with some aspect of the medium.

In the two decades since the founding of The Friends, national-level interest in creative photography has increased tremendously; and, in response to the medium's new public popularity, museums throughout the country have expanded their photography exhibition programs. A measure of this popularity can be seen in the recent exhibition of photographs by Ansel Adams at the National Gallery in Washington, D. C., which drew an unprecedented audience of 651,752 during its four-month run. It can also be seen in the growing number of institutions of higher learning that have created courses of study in photography. Today, almost every college and university in the country teaches creative photography, and these programs have not only fed the pool of practicing artists, but have also engendered a knowledgeable and increasingly sophisticated audience. The Friends has fostered this growth through its programs in exhibitions, publications, education and grants to photographers. What the organization has become today both reflects and is a result of this great public acceptance of photography.

Before describing the development of The Friends of Photography, it is fascinating to review some events of the world stage two decades ago, in the founding year of the organization. 1967 was the first year the Super Bowl was played. It was the year *Rolling Stone* magazine began publication and a year of many protests against the war in Vietnam. The "Summer of Love" was celebrated in San Francisco's Haight-Ashbury district. During 1967, the six-day Arab Israeli war took place, and President Lyndon B. Johnson appointed Thurgood Marshall to the Supreme Court. Painters René Magritte and Edward Hopper died, as did folk singer Woody Guthrie. Major films included Michaelangelo Antonioni's *Blow-up* and Arthur Penn's *Bonnie and Clyde*. The People's Republic of China exploded its first hydrogen bomb, and Dr. Christiaan Barnard performed the world's first human heart transplant operation. Mickey Mantle hit his five-hundredth career home run. Twiggy became the fashion sensation in a miniskirt. 3.6 million people were born in the United States, and the cost of living went up 1.8 percent.

Both the city of Carmel-by-the-Sea and the Monterey Peninsula region of which it is a part have been havens for artists for decades. Perhaps it was the photogenic natural beauty of the Pacific coastline here that first attracted photographers; but, whatever the cause, the effect was that the area became a magnet, particularly for those whose roots were in the $f/64$ tradition. In fact, two artists who were the linchpins of that tradition and who are among those who have had the greatest influence on twentieth-century photography resided in Carmel. Edward Weston's name became fully associated with Carmel after he moved here in the late 1920s, and he worked here until his death in 1958. Just four years later, in 1962, a second major artist, Ansel Adams, moved to the Carmel area from San Francisco. There have been many other less well known, though fully accomplished, creative photographers who have also made their homes in the area.

Ansel Adams had been a founder of many important photographic institutions before he moved to Carmel. In the 1930s, Adams was both a founder and an active participant in Group $f/64$; in the 1940s, he was a founder of the photography department at the Museum of Modern Art in New York City, and he started the photography department at the San Francisco Art Institute; in the 1950s, he was a founder of the journal *Aperture* and began his annual photography workshops, an educational program he had offered sporadically since 1940, in Yosemite National Park. Thus it was natural for Adams, shortly after his arrival here, to seek an association of local photographers with national interests.

Since historian Beaumont Newhall has written elsewhere in this volume his record of the founding of The Friends, I will not detail those events. It is significant, however, that none of the founders had been born in Carmel and that their interests in photography reached to the nation and the world. The Newhalls, in fact, still lived in Rochester, New York, although at the time they had plans, never realized, to build a home in Carmel adjoining that of the Adams. It was thus clear from the start that The Friends would not be a local camera club, even in the best sense of that term, but rather a non-profit organization that would seek to promote creative photography throughout the world. The Friends was begun, as Ansel would say,

"as a beacon." It was to be an independent organization that would support and strive for the highest possible quality in the medium.

By 1966, the city of Carmel-by-the-Sea had assumed ownership of an elementary school complex a few blocks south of the village business district and had decided to transform it into a community cultural center. Cole Weston, the building's manager, responding to the enthusiasm of those who had gathered at Ansel's home that day in January of 1967 to form The Friends, offered rental space in the new Sunset Cultural Center.

On January 30, the first Board of Trustees was formally elected. Ansel Adams was president; Brett Weston, vice president; Edgar Bissantz, second vice president; Rosario Mazzeo, secretary; and Art Connell, treasurer. Their first action was to incorporate the group as The Friends of Photography. The articles of incorporation were filed with the state on February 8; non-profit, educational 501(c)(3) status was received in June.

The Board of Trustees, who at this point were the only members as well as the only volunteer workers, outlined the activities they wished to pursue. The first two programs were to be exhibitions and education. A publishing program, even though it would reach greater numbers of people, would have to wait for two years until these initial, local programs were in place. Committees were established, and the Board attended to transforming what had been a school library into The Friends of Photography Gallery at Sunset Center. Men like Rear Admiral Edward Forsyth and George Short worked with commitment; and, aided by a few other volunteers, The Friends was able to open its first exhibition on June 23. This initial presentation included photographs by Ansel Adams, Brett Weston, Edward Weston, Wynn Bullock, Imogen Cunningham, Dorothea Lange and Minor White. The Board also established the Monterey Workshops in Creative Photography and were able to use the facilities of Monterey Peninsula College for the first sessions.

In the same way that he had been the catalyst of The Friends' founding, Ansel Adams was clearly the organization's foremost member prior to his death in 1984. In his autobiography, published posthumously in 1985, Adams wrote, "The Friends has given me the opportunity to understand my medium better in relation to the photographic community at large. It has been the most rewarding and important association during the Carmel chapter of my life." Ansel's vision of the organization served to guide it for many years.

In 1978, Ansel became chairman of the Board of Trustees, and Peter C. Bunnell was elected president. A professor of the history of photography and modern art at Princeton University, Peter has been very involved in most of the country's important creative photography institutions over the past several decades. None of these has received more of his energies than has The Friends, and his effective leadership at the Board level has given the organization a powerful base of support for program expansion. The Board again changed its leadership structure in 1987, when it elevated Peter Bunnell to chairman, a position that had been left vacant since Ansel's death in 1984, and elected San Francisco businessman Richard N. Goldman as its president.

The early members of the Board of Trustees invested enormous amounts of volunteer time

in creating an effective exhibition and teaching program. Their efforts were quickly joined by others on the Monterey Peninsula who supported The Friends' goals. This second group of Trustees dedicated to keeping the organization moving forward included three seriously committed photographers: city planner Richard Garrod, attorney Robert Byers and Monterey County sheriff Henry Gilpin. At that time, Wynn Bullock became the head of the exhibitions committee, a position he held until 1973. After his death in 1976, The Friends Gallery in Carmel was named in his honor. It was the success of all the volunteers in the early 1970s and their interest in doing more that created the necessity of hiring a staff to oversee the day-to-day operations.

As the need for full-time, professional leadership became apparent, the Board created the position of executive director. This person, who serves as The Friends' chief administrative officer, is hired by the Board of Trustees to carry out its policies and to run the organization. The executive director, in turn, hires the staff and is responsible for the operation of programs. In the period since activities were carried out by a volunteer staff, there have been only four executive directors. The first was William A. Turnage. Bill was appointed in 1972 to set up the systems and staff, and to initiate a period of growth for the organization. He went on to work as Ansel's business manager for several years before becoming the executive director of The Wilderness Society in Washington, D.C. Bill was followed by Fred Parker, a young man with a broad vision of The Friends' mission and an interest in concerns beyond those typically thought of as photographic. Fred began the *Untitled* series and initiated such diverse programs as the "Creative Experience" workshop; his exhibition program was wide ranging and aggressive.

In retrospect, Fred tried to move the organization considerably faster than the Board was prepared for, and his departure prompted much introspective consideration of the appropriate mission of The Friends. A Committee on the Future of The Friends, chaired by educator John Upton, was created to study the situation; and the document they produced, the COFF report, thoughtfully pointed a direction. While there was no executive director in title during this interim period, retired insurance executive Bill Rusher, who was president of the Board, became the skillful administrator who served in the director's role. Bill was the diplomat who resolved the conflicts.

In 1976, with Ansel's full backing, the Board was ready to confirm the original mission of the organization and to act forcefully to seek a new director and move The Friends ahead. Jim Enyeart, a historian of photography who had been the director of the art museum at the University of Kansas, was hired and brought increased professionalism to this organization. After just a year, however, Jim determined that a university setting was more appropriate to his interests, and he became the director of the Center for Creative Photography at the University of Arizona in Tucson.

When I was asked in the spring of 1977 if I would assume the position of executive director, I accepted with delight. Not only would the job give me the opportunity to build an organization I believed in, but I would be able to live in the rich photographic milieu of Carmel and

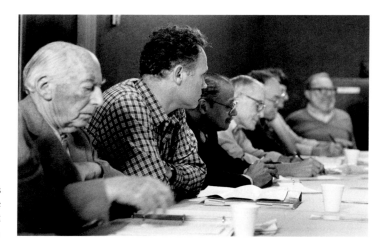

Members of the Board of Trustees meet each March to review the past year's activities and to set policy for The Friends.

learn from Ansel Adams. Having been the chairman of the Board of Directors of the Society for Photographic Education, I felt I had some understanding of a small non-profit photography organization's administrative needs, as well as a vision for what an organization such as The Friends could do. I had been the editor of the SPE's journal, *Exposure*, so I had publishing experience similar to that of the *Untitled* series. I had also served as a curator in organizing exhibitions for the Sheldon Art Gallery and the Mid-America Arts Alliance; and since I had spent the prior decade as a professor of photography, I felt somewhat confident regarding our education program.

During the ten years I have served as executive director of The Friends, I have enjoyed a curiously wonderful mix of assignments: part curator, part publisher, part teacher, part administrator. As the organization grew in size and complexity, though, administrative duties took up increasing quantities of time, and the staff was enlarged to fill the diversity of needs. Feeling the desire to return to personal creative work as a photographer and to pursue other curatorial and publishing projects, I submitted my resignation in the winter of 1986. Happily, the national search for my successor was successfully conducted, and the Board of Trustees hired an outstanding arts administrator, Lynn J. Upchurch, who will assume her responsibilities as The Friends' fifth executive director at the midpoint of 1987.

Over the past decade, many photography non-profits have come and gone, but The Friends has thrived. I am often asked how The Friends went from the small thousand-member group that existed in 1977 to one that, during the 1980s, developed to 10,000, and then on to 15,000 members—the largest creative photography membership organization in the world. The simplest answer is quality programming, supported by much hard work. By the early 1980s, it was clear to me that there was a large, significant audience deeply interested in creative photography, yet there was no regularly published periodical directed at the serious photography audience. Those few non-profit photography publications that did exist either were too eso-

teric or were published irregularly, and the commercial magazines appealed largely to hobbyists. Thus I initiated a series of large direct mail campaigns to introduce The Friends of Photography to the world. The audience that I believed was there responded.

In order to maintain our quality of membership benefits, we had to increase all of our systems dramatically. I insisted upon regular communication with our members, so every month they received a newsletter, and several times a year they were sent an exquisitely printed book. The original photographs offered through the Collectors Print Program, which began as the Sustaining Print Program in 1972 and which provides signed fine prints by important photographers to upper-level members, was significantly enhanced. It has been an important program in its support of artists, in its advantage to members and in its support of The Friends' budget. The responsibility for maintaining the membership records and coordinating the membership campaigns fell to Nancy Ponedel from 1974 to 1982, to Robin Venuti from 1982 to 1985 and to Sandra McKee from 1986 to the present. In 1983, in-house computerized membership records were installed, since accurate record keeping is critical to a membership organization.

While The Friends' largest single income source is membership revenue, other major proceeds are derived from the wholesale and retail sales of our books and from special offers of fine prints and books to members. These earned income sources total about ninety percent of our income. For many museums, earned income is often only half of the total revenue, with gifts and grants from individuals, foundations, corporations and governmental units forming the other half. I believed that these sources were largely unreliable, particularly for a small organization headquartered in Carmel, and shrinking government support for the arts over the past several years has, in fact, been a difficult reality for many non-profits who have relied too heavily on such unearned income. While a plurality of sources is necessary, earned income must be generated to survive; our very high ratio of earned income has provided the possibility of growth.

Financial stability has been a very important ingredient in the success of The Friends. In 1979, to begin our endowment, I organized a major auction at Christie's East in New York City. The auction resulted in over $225,000 being raised in a single afternoon of exciting bidding; and, under the direction of the Board's Finance Committee, the endowment has more than doubled since that time. It provides a psychological cushion, an ongoing sense that the organization has backing beyond its annual income.

Since its founding, the gallery and offices of The Friends have been located in the Sunset Cultural Center, on San Carlos Street between Eighth and Ninth in Carmel-by-the-Sea. Greatly increased activities led to the leasing of both additional offices in a separate building a block away and warehouse space in Monterey. While these fragmented facilities, too, were soon outgrown, the dedicated staff has continued to serve our expanded audience successfully. Certain of those staff have made vital contributions, yet they rarely receive deserved credit. Thus I would like to recognize administrative assistants Nancy Ponedel, Debbie Bradburn, Peggy Sexton, Pam Feld and Lorraine Nardone; finance office workers Machelle Dawn-Greer,

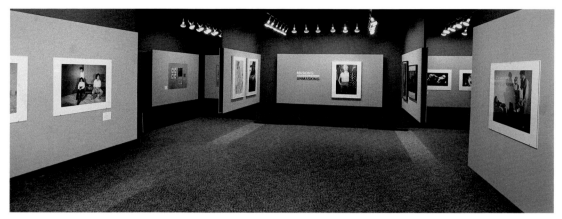

More than two hundred exhibitions have been shown in The Friends of Photography Gallery in Carmel's Sunset Cultural Center. Shown here is the 1984 exhibition *Masking/Unmasking: Aspects of Post-Modernist Photography.*

Phyllis Winston and Gail Edwards; gallery attendants Robert Thompson and Emily Bennett and our full-time volunteer John Breeden.

As the first, and thus the longest running of our programs, exhibitions have been a very important part of our contribution. The gallery of The Friends was one of the first in the country devoted exclusively and independently to the exhibiting of fine photography; and over the past twenty years, we have displayed an extraordinary variety of photographic ideas. Often, exhibitions at The Friends have provided early recognition for young artists who have later become leaders in the field. Since our gallery was in Carmel, rather than in a major metropolitan setting, traveling exhibitions became a way to reach a large audience. Millions of viewers have seen the exhibitions we have mounted—not just in the Carmel gallery, but in institutions from San Francisco to New York, from New Delhi to Venice to Shanghai.

The content of each of the more than two hundred exhibitions that have been shown in the Carmel gallery has been determined by the curator, and while each of the executive directors has played a curatorial role, that staff position has also been held by others: Peter Hunt Thompson (1971 to 1973), Charles Desmarais (1973 to 1974), Rod Stuart (1974 to 1976) and David Featherstone (early 1980s until now.) The exhibitions are installed by the staff, and after the staff grew, certain individuals had that specific task: Peter Andersen (1976 to 1981), Libby McCoy (1981 to 1984), JoAnn Yandle (1984 to 1987) and, presently, Cloyce Wall.

Educational seminars and practical workshops have been a part of The Friends' primary mission since 1969. These successful programs have allowed thousands of young artists and photography students to work with a faculty that has included many of the most important photographers in the world. An intense, high level of instruction has been presented consistently. Along with seminar rooms that are available at Sunset Center, we have often rented other facilities for the workshops at the Asilomar Conference Center in Pacific Grove, the Hid-

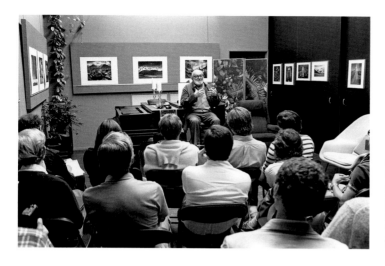

Ansel Adams' home and studio in Carmel Highlands was a meeting place for many kinds of photographic groups. Here, he meets with a group of students at The Friends' 1983 Ansel Adams Workshop.

den Valley Institute for the Arts in Carmel Valley and the Robert Louis Stevenson School in Pebble Beach. By 1980, the workshop program had grown so large that a full-time administrator was required. The first of these was Mary Virginia Swanson, who served from 1980 to 1984. Swan was followed by Claire V. C. Peeps, from 1984 to 1985, and, after her, by Julia Nelson-Gal.

As is appropriate to an organization with a primarily national membership, The Friends' publications have been our most visible program, and our commitment to quality has become widely known. These publications emphasize photography as a fine art and explore the history and criticism of the medium. The most well-known of these is the *Untitled* series, and the full range of the more than forty *Untitled* issues can be seen clearly in *The Record*, at the back of this volume.

A variety of special books has also been published by The Friends over the past decade. The 1979 volume of Carleton Watkins' photographs of the Columbia River and Oregon, which reproduced a long-lost photographic album, won the book-of-the-year award at the international photography festival in Arles. Our major retrospective book of the remarkable artist Robert Heinecken broke new ground in monograph publication in 1981, and with the publication in 1983 of *Overexposure: Health Hazards in Photography*, by Susan Shaw, The Friends shared important research in health concerns with all photographers.

Since the reproduction of photographs is the single most important ingredient of our books, I felt compelled to research the best possible printing of black and white photographs. I found a printer in Southern California, David Gardner, to be the very best and have retained him to do most of The Friends' book printing over the past decade.

A newsletter is an obvious way to keep members informed. One was started in 1970, and eight irregularly released issues appeared over the following two years. I felt that a regular newsletter was critical to the growth of The Friends and established that as a priority as soon

Richard Koshalek, director of the Museum of Contemporary Art in Los Angeles, served as juror for the initial year of the Ruttenberg Fellowship.

as I became executive director. Our newsletter has been published, usually as a four-page issue, each month since January of 1978. After almost a decade, feeling that a new design and enlarged content were needed, we developed a revised, eight-page newsletter. Renamed *re:view*, the first issue was released in January of 1987. *re:view* now contains book reviews, interviews, essays and news of Friends' activities as well as other news in the field. Members of The Friends receive both *Untitled* and *re:view* as benefits of membership.

The editorial, design, production and distribution functions of The Friends' publishing program have all been handled by staff members. The content of the newsletter over the past few years has been under the direct control of Claire Peeps (1982 to 1984), Julia Nelson-Gal (1984 to 1985) and, most recently, Linda Bellon-Fisher. We have been fortunate to have outstanding in-house designers for our publications. Peter Andersen served from 1977 to 1984; Desne Border from 1985 through early 1987. The handsome publications they designed frequently received prestigious awards.

Writing about art is too often obscure and frequently threatening, and I have always felt that there is no excuse for such ponderous material. Fortunately, The Friends has had a staff member in charge of editorial productions who not only agrees, but who writes clearly himself. David Featherstone came to The Friends in 1977, and the organization's success is due in good measure not only to his remarkable abilities, but also to the continuity of his tenure. The quality of his input into all areas of The Friends' programs and administration have demanded that his responsibilities increase over time, and David is now the associate director.

In all the selections that must be done in programming, one necessarily becomes an arbiter of taste. Nowhere would that seem more obvious than in our programs of grants and awards to artists, yet the staff and trustees do not determine any of the winners. These decisions are all made by independent jurors or peer group members. The Friends gives two grants each year. The Ferguson Grant was established in 1972 to recognize the work of a young photographer,

and the Ruttenberg Fellowship was established in 1981 to support the completion of a photographic project. Different jurors are appointed each year in order to vary the criteria for selection, and these jurors approach their tasks seriously. It is indicative of their broad views that a juror's personal creative concerns are rarely similar to those of the grant recipient they select.

In 1980, the Board of Trustees established the Peer Awards in Creative Photography in order to give recognition to senior figures in the field. A group of over 250 independent photographers, critics, curators, historians and collectors were asked to serve as nominators and electors. Each year these peers are sent a blank ballot on which they write the name of the person they think most deserving of the two Peer Awards—Distinguished Career in Photography and Photographer of the Year. The first two winners, respectively, were Harry Callahan and Lee Friedlander, and the choices have been equally compelling each year.

The celebration of The Friends' first two decades of service coincides with an additional transition in our history—that of moving our operations from Carmel to San Francisco. We are evolving from a national membership organization with a gallery in a small town to a major urban art center with an even stronger national and international following.

The death of Ansel Adams on April 22, 1984, created a period of introspection for The Friends, one from which the concept of developing the Ansel Adams Center as our permanent home evolved. The Board agreed that it was appropriate for us to create the Center as a testament to Ansel's spirit and to his enthusiam for the future of the creative medium in which he so eloquently expressed himself. It was first felt that the Center should be located on the Monterey Peninsula, since Ansel lived here at his death and because The Friends had always been here. After a year of studying numerous site possibilities, however, it was determined that a satisfactory location was not available here and that the Peninsula's financial and political climate would not allow such a new cultural center within the foreseeable future.

The decision to relocate The Friends to San Francisco came after careful study by both the staff and the Board of Trustees. Since Ansel Adams was born in San Francisco and resided there for the first sixty years of his life, it was seen as fitting for a facility bearing his name to be located there. Similarly, because San Francisco has held a special place in the history of creative photography since the 1860s and because it is nationally known for its many cultural resources, the city is a natural home for the Ansel Adams Center.

There is a very significant viewing audience residing in the greater Bay Area that truly appreciates fine photography. There are also some two dozen colleges and universities in the area that teach photography. The millions of tourists who visit San Francisco each year will provide an additional audience for the galleries and other programs of the Center. The photography displayed on the walls of the four major exhibition galleries will offer visitors the richest single-site display of fine art photography outside of New York. One gallery will be permanently devoted to displaying Ansel Adams' photographs; the others will honor past achievement in the medium and feature the best of contemporary photography.

The education area of the Center will enable The Friends to expand greatly on the workshops and lectures we have presented over the past two decades. The facilities will include a

demonstration darkroom, a photography studio, seminar rooms, an auditorium, a library and staff offices. The Center will also have significantly increased work space that will allow a much more efficient continuation of the *Untitled* book series, the newsletter *re:view* and new publishing projects.

It is my view that through its exhibitions and its other educational programs, the Ansel Adams Center will offer rich encounters with the past, with what exists now and with what is possible. It will stimulate creativity, give pleasure and increase knowledge. The photography exhibitions will acquaint us with the unfamiliar, coaxing us beyond the safety of what we already know. They will also impart a freshness to the familiar, disclosing miracles in what we have long taken for granted. The Ansel Adams Center will be a gathering place, a place of discovery, a place to find quiet, to contemplate, to be inspired.

Ideas and plans such as these have little value without the dollars necessary to make them a reality. While the Board of Trustees of The Friends employed some early fund raising counsel for our capital campaign, my administrative assistant Pam Feld and I assumed the direction of the campaign itself. The concept of the Ansel Adams Center proved a workable one, and many individuals came to our support. First, Virginia Adams, President Gerald Ford and President Jimmy Carter provided distinguished leadership as the Honorary Chairpersons of the campaign for the Center. Trustee Joan D. Manley rallied her peers on the Board; and, with one hundred percent support, the Trustees came forward with significant contributions. Individual members of The Friends were most responsive, and photography manufacturers ranging from Kodak to Oriental to Polaroid all pledged important funds. An active Trustee committee urged Bay Area foundations, the Richard and Rhoda Goldman Fund and the Walter and Elise Haas Fund prominent among them, to provide the capital campaign with urgently needed dollars. They responded positively, as did San Francisco-based corporations such as Wells Fargo Bank. By the end of 1986, we had received more than $2.5 million in contributions. While the search for funds was carried on, another Trustee committee headed by Kay Dryden, Peter Henschel and Leonard Vernon conducted a successful study of the feasibility of a San Francisco location. Ansel's dream of a permanent home for The Friends will indeed become a reality.

The Friends of Photography's international reputation for the highest quality programs and publications guarantees the enduring importance of the Ansel Adams Center over the next decades. An editorial in the June 16, 1986, San Francisco *Chronicle* declared that, as the new headquarters of The Friends, "The Ansel Adams Center will be of international importance the day its doors are opened." That facility and the programs presented in and through it will form the basis of the contributions The Friends will make in the future.

In the past two decades, The Friends of Photography has grown and matured into a truly professional public service organization. In its nurturing of the flourishing public interest in creative photography, The Friends has enriched many lives. Having had the opportunity to play a central role in its most recent decade has certainly enriched my life.

The Friends has made a difference.

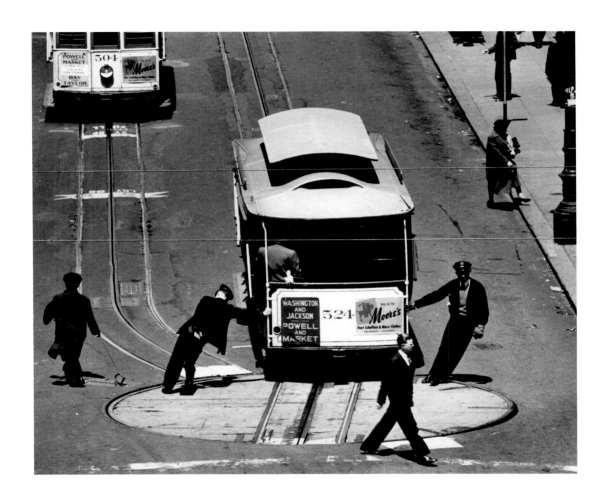

Max Yavno. *San Francisco*, 1947.

Jerome Liebling. *George Wallace, Minneapolis, Minnesota*, from the *Politics* series, 1968.

Bill Owens. Untitled, from *Suburbia*, 1970.

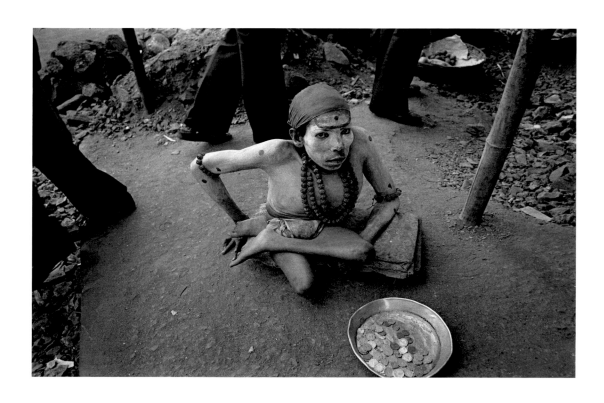

Mary Ellen Mark. *Cross-Legged Beggar*, 1978.

Bruce Davidson. Untitled, from *East 100th Street, New York*, 1966–1968.

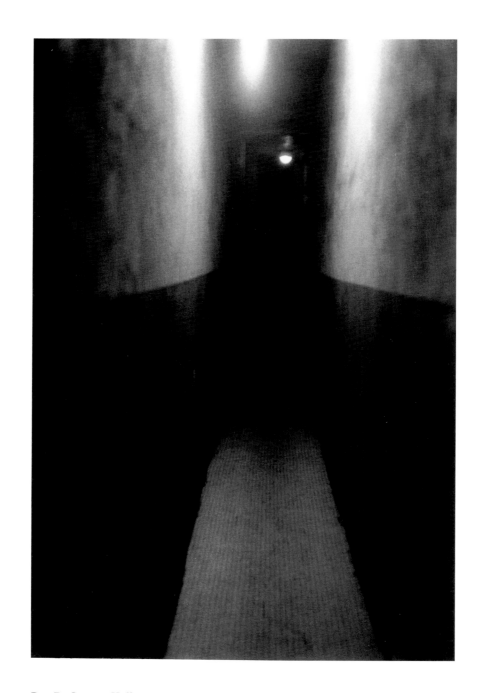

Roy DeCarava. *Hallway*, 1953.

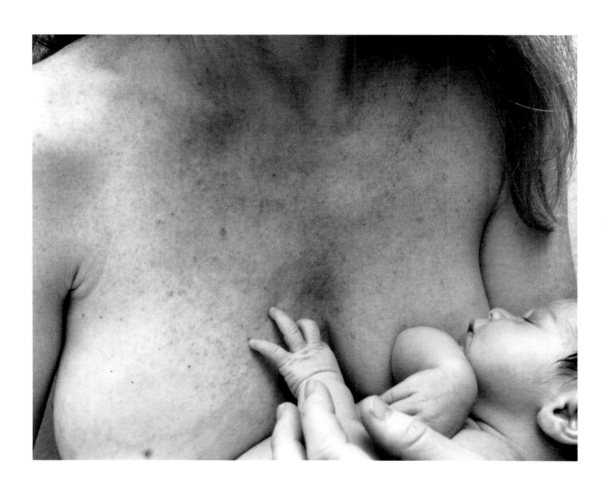

Nicholas Nixon. *Clementine, Cambridge*, 1985.

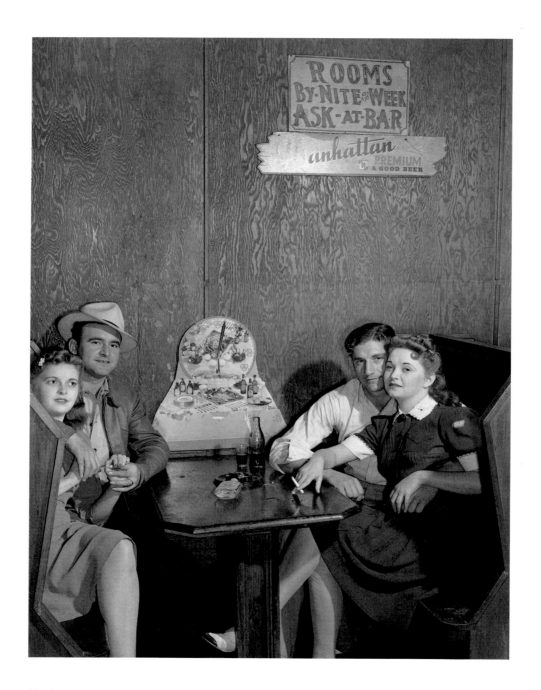

Marion Post Wolcott. *Two young couples in a juke joint, near Moore Haven, Florida,* 1939.

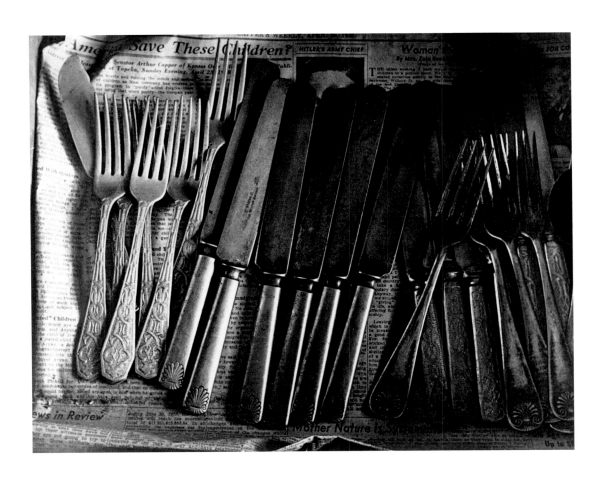

Wright Morris. *Drawer with Silverware, Home Place*, 1947.

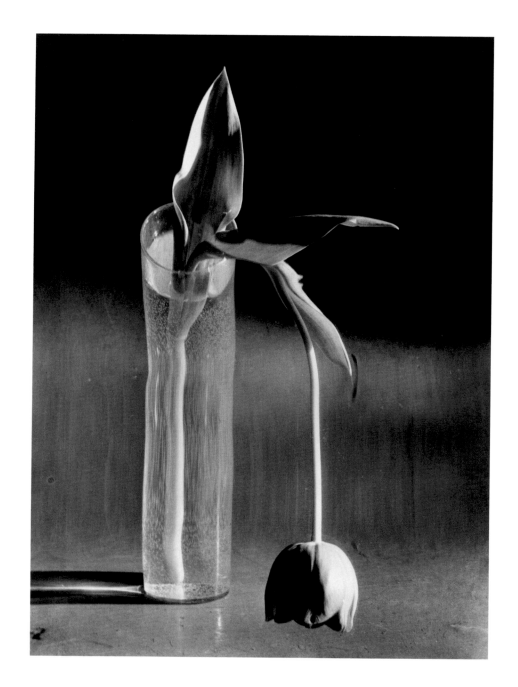

André Kertész. *Melancholic Tulip, New York*, 1939.

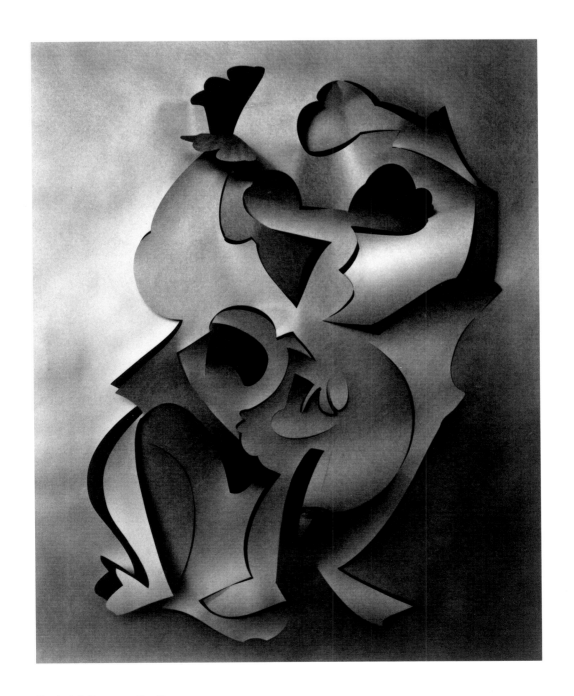

Frederick Sommer. *Cut Paper*, 1977.

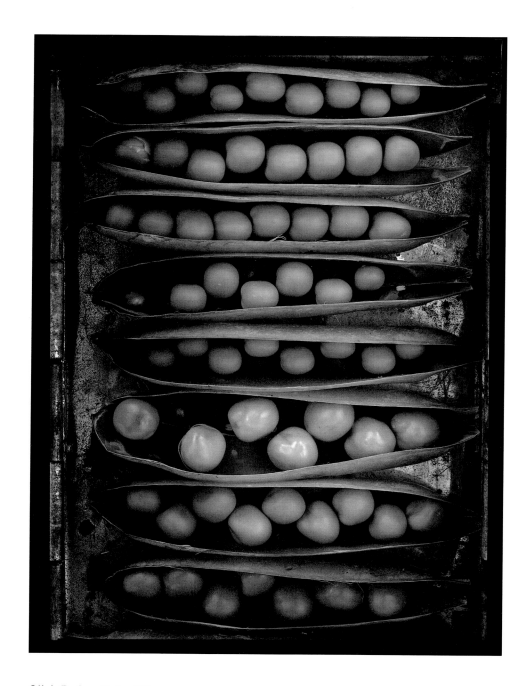

Olivia Parker. *Pods of Chance*, 1977.

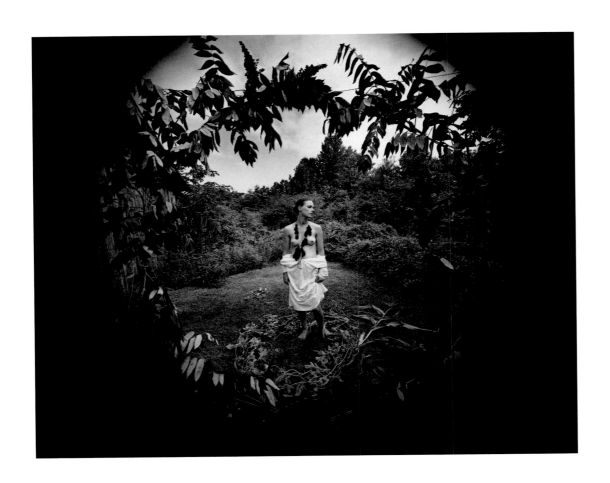

Emmet Gowin. *Edith, Danville, Virginia,* 1971.

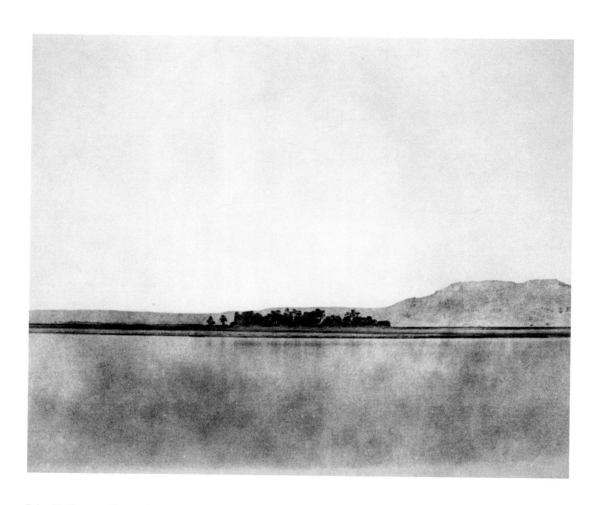

John B. Greene. *Luxor, Egypt*, c.1853–1854.

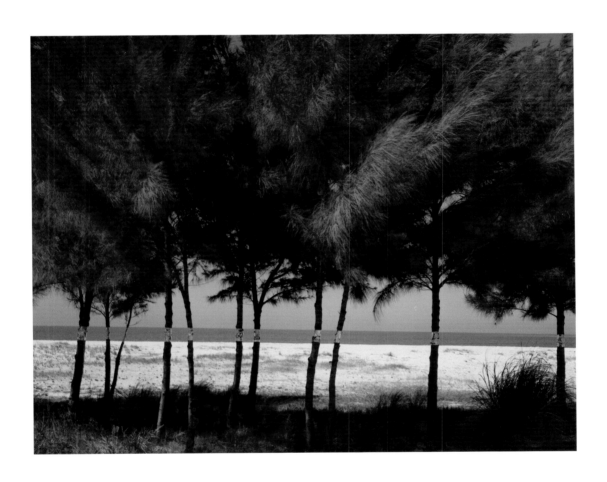

John Pfahl. *Australian Pines, Fort DeSoto, Florida*, 1977.

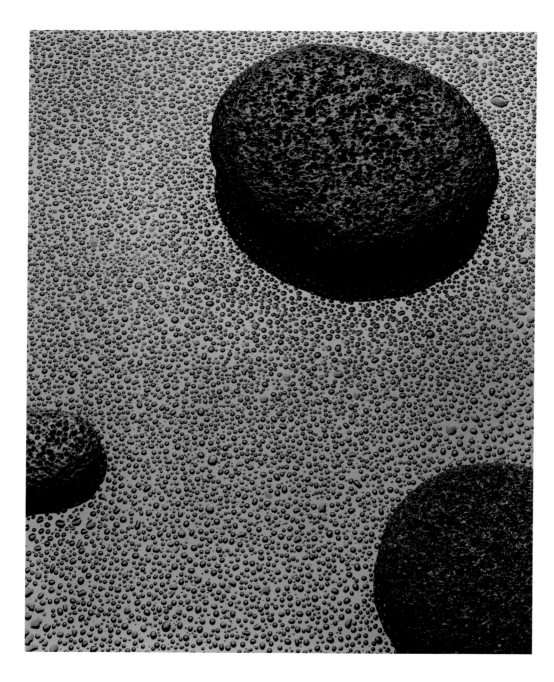

Don Worth. *Three Volcanic Beach Stones and Rain Drops*, 1985.

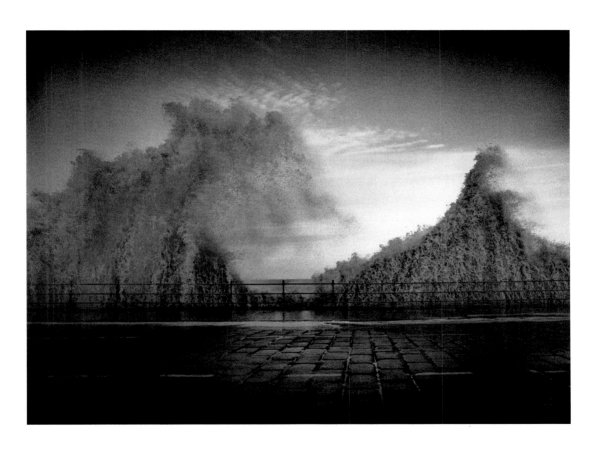

Michael Kenna. *Wave, Scarborough, Yorkshire, England*, 1981.

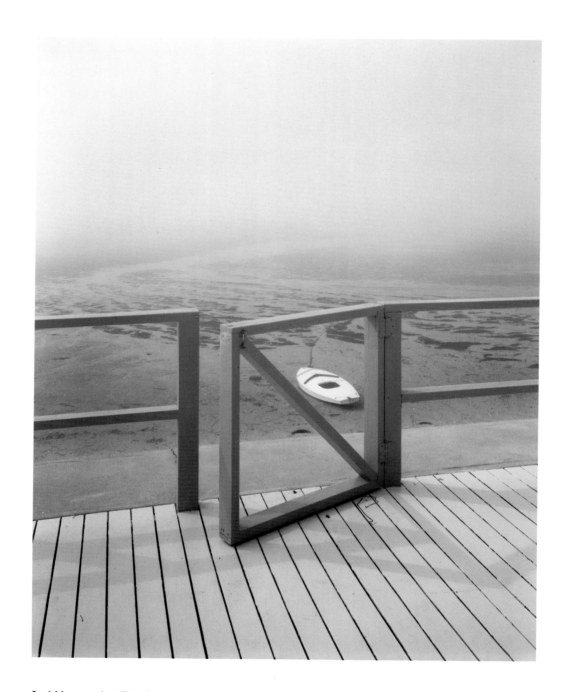

Joel Meyerowitz. *Provincetown*, 1977.

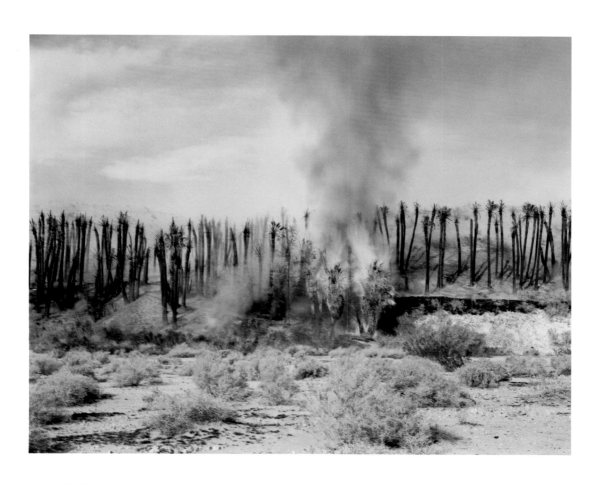

Richard Misrach. *Desert Fire #1*, 1983.

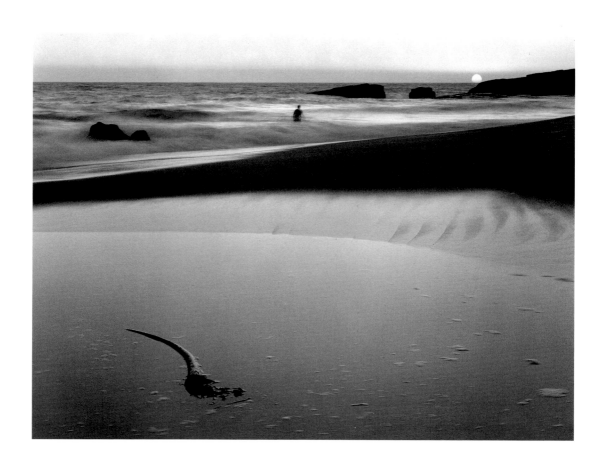

John Sexton. *Sunset, Panther Beach, near Santa Cruz, California*, 1979.

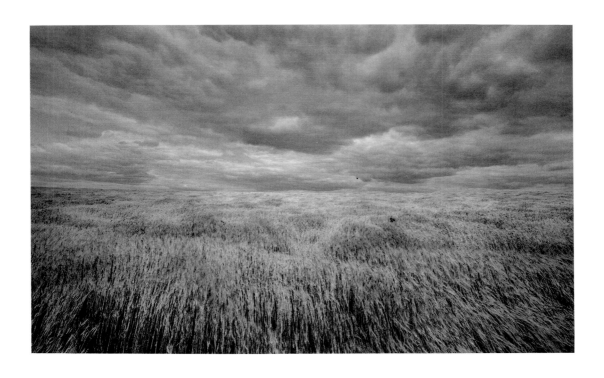

Lawrence McFarland. *Wheatfield*, 1976.

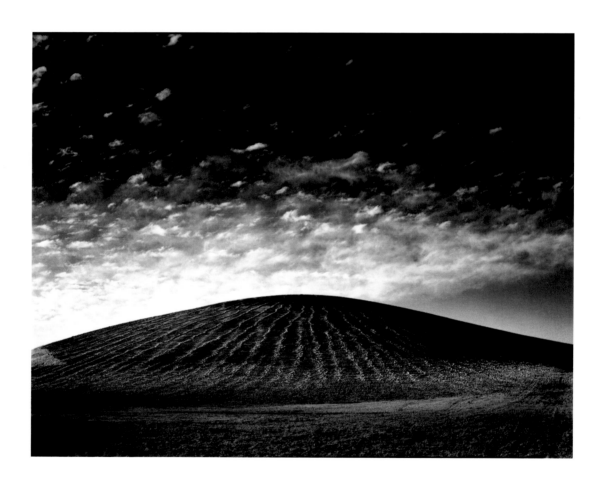

Morley Baer. *Farm Knoll, Contra Costa*, 1970.

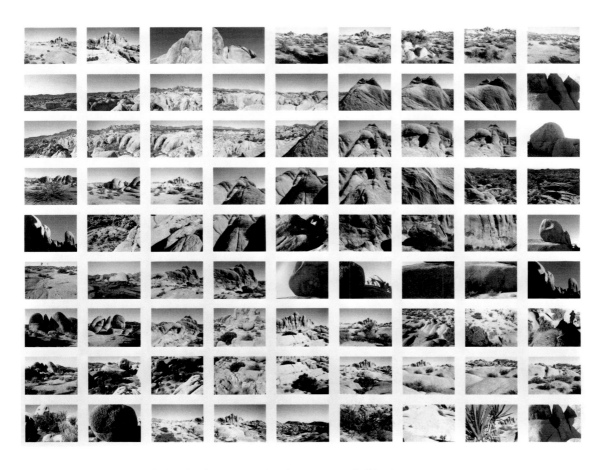

Robbert Flick. *Near Live Oak 1, Joshua Tree National Monument, California*, 1981.

Lee Friedlander. *Toyko*, 1977

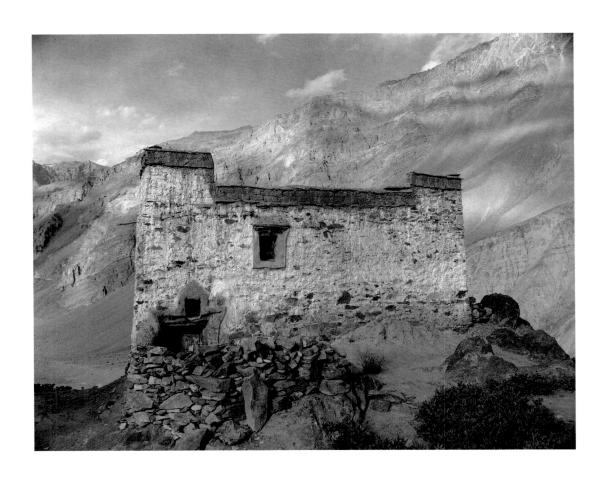

Linda Connor. *Monk's Residence, Zanskar, India*, 1985.

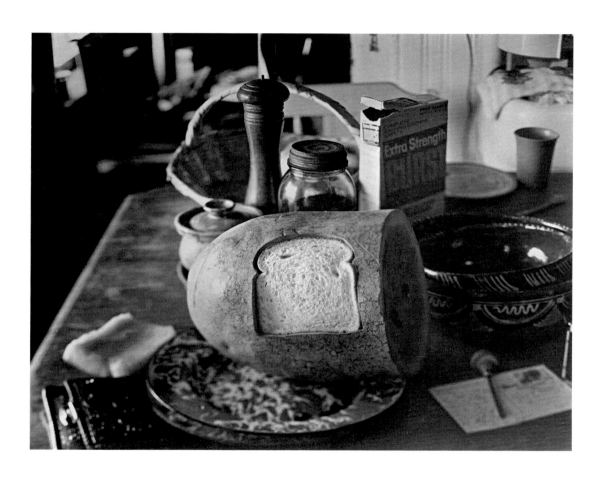

Robert Cumming. *Watermelon/Bread*, 1970.

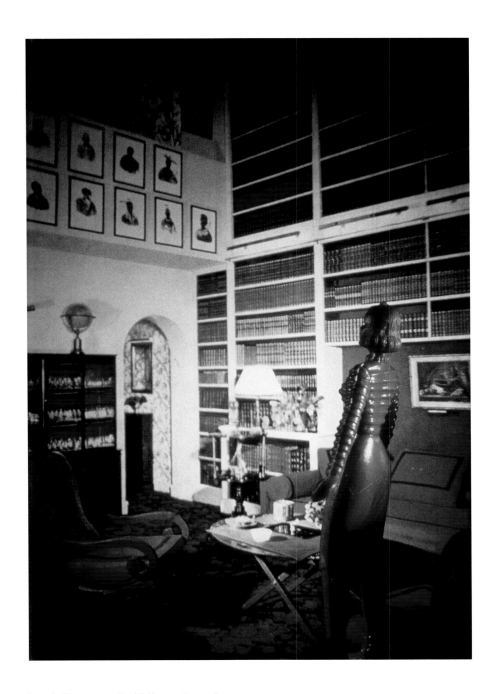

Laurie Simmons. *Red Library #2*, 1983.

My wife is Acceptable.
Our relationship is satisfactory.
Edgar G.

Edgar looks splendid here. His power and strength of character come through. He is a very private person who is not demonstrative of his affection; that has never made me unhappy. I accept him as he is.
We are totally devoted to each other.
Regina Goldstine

Dear Jim:
May you be as lucky in marriage!

Jim Goldberg. *Untitled*, from the series *Privileged of San Francisco*, 1981.

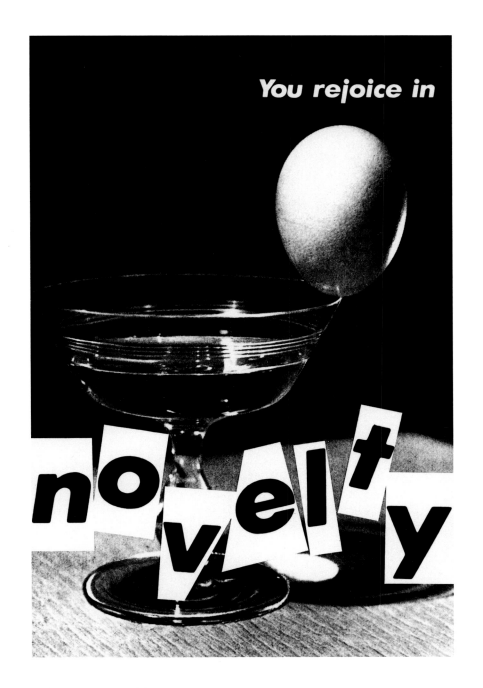

Barbara Kruger. Untitled, 1984.

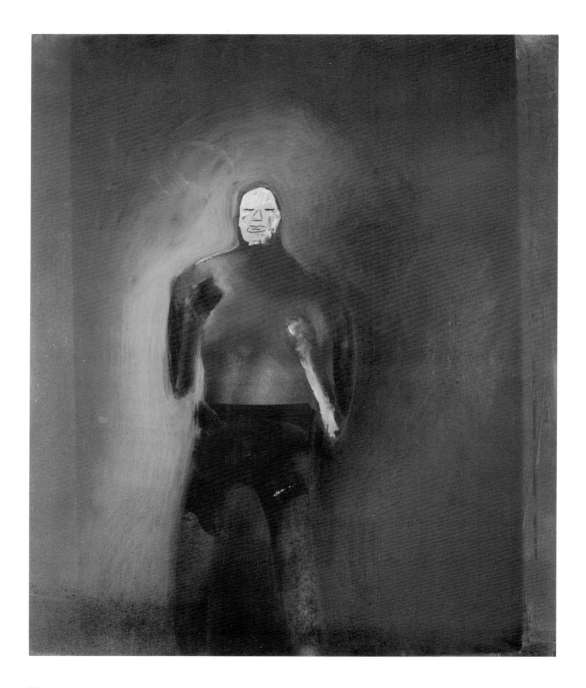

Holly Roberts. *Mexican Boxer*, 1986.

The Record 1967–1987

BOARD OF TRUSTEES

The group that founded The Friends of Photography in Carmel in 1967 included eleven individuals; the first Board consisted of eighteen Trustees. Members of an Advisory Committee, which was created in 1967, were formally designated as Advisory Trustees in 1974. The position of Honorary Trustee was established in 1985.

Ansel Adams
Founding Group
Trustee, 1967–1984
President, 1967–1974
Chairman, 1974–1984

Virginia Adams
Honorary Trustee, 1985–

James G. Alinder
Trustee, 1987–
Vice President, 1987–

Morley Baer
Founding Group
Trustee, 1973–1982
Advisory Trustee, 1982–

Robert Baker
Advisory Trustee, 1979–1980
Trustee, 1980–
Second Vice President, 1981–1982
Vice President, 1982–1987

Thomas F. Barrow
Advisory Trustee, 1985–1986
Trustee, 1986–

Peter Besag
Advisory Trustee, 1975–1977

Edgar Bissantz
Founding Group
Trustee, 1967
Advisory Committee, 1967–1973

Wynn Bullock
Founding Group
Trustee, 1967–1976
Vice President, 1971–1976

Peter C. Bunnell
Advisory Trustee, 1973–1974
Trustee, 1974–
Vice President, 1976–1978
President, 1978–1987
Chairman, 1987–

Shirley Burden
Advisory Committee, 1970–1973
Trustee, 1973–1980
Advisory Trustee, 1980–1983

Robert K. Byers
Trustee, 1969–
Treasurer, 1970–1987
Vice President, 1977–1978

Carl Chiarenza
Advisory Trustee, 1980–1983

Van Deren Coke
Advisory Committee, 1967–1973

Arthur Connell
Founding Group
Trustee, 1967–1973
Treasurer, 1967–1970

Linda Connor
Advisory Trustee, 1985–

Robert Corrigan
Advisory Trustee, 1973–1977

Barbara Crane
Trustee, 1975–1982

Stephen Crouch
Trustee, 1973–1978

Imogen Cunningham
Advisory Committee, 1967–1973

William Current
Trustee, 1967–1969

Margo Davis
Trustee, 1974–1977

Roy DeCarava
Trustee, 1983–1985

Albert Dorskind
Trustee, 1982–
Vice President, 1983–1987

Phyllis Kay Dryden
Advisory Trustee, 1984–1985
Trustee, 1985–
Secretary, 1985–1986
Vice President, 1986–

James Enyeart
Trustee, 1978–1981
Vice President, 1978–1980
Advisory Trustee, 1981–1982

Frederick S. Farr
Advisory Committee, 1967–1973

George J. Faul
Trustee, 1982–

James C. Flood
Advisory Trustee, 1987–

Rear Adm. Edward C. Forsyth
Trustee, 1967–1975
Advisory Trustee, 1975–1979

Bernard Freemesser
Advisory Trustee, 1975–1977

R. Buckminster Fuller
Advisory Committee, 1967–1973

73

STAFF

During the early years of its history, operations of The Friends were carried out by volunteer committees headed by members of the Board of Trustees. The first paid, full-time professional staff was hired in 1972. As the staff has grown since that time, job titles and responsibilities have changed greatly.

Executive Administration

Other Staff

Machelle Dawn-Greer
Controller, 1984–1987

Charles Desmarais
Curator, 1973–1974

Cheryl Douglas
Curator, 1974

Gail Edwards
Accounting Supervisor, 1987–

David Featherstone
Executive Assistant, 1977–1980
Executive Associate, 1980–1986
Associate Director, 1987–

Pam Feld
Administrative Assistant, 1982–1986
Executive Assistant, 1986–1987

Jane Garrison
Membership Assistant, 1986–

Libby McCoy
Gallery Technician, 1981–1984

Sandra McKee
Membership Director, 1986–

Lorraine Nardone
Secretary/Receptionist, 1985–

Julia Nelson-Gal
Executive Assistant—Editorial,
1984–1985
Executive Assistant—Workshop Coordinator, 1985–1986
Education Director, 1987–

Claire Peeps, Executive Assistant—
Editorial, 1982–1984
Executive Assistant—Workshop Coordinator, 1984–1985

Nancy Ponedel
Secretary/Assistant to the Director,
1974–1982

Peggy Sexton
Secretary, 1982

Kerry Sisson
Shipping/Receiving, 1987–

Rodney C. Stuart
Curator, 1974–1976

Mary Virginia Swanson
Executive Assistant—Workshop Coordinator, 1980–1984

Peter Hunt Thompson
Curator, 1971–1974

Robert Thompson
Gallery Attendant, 1977–1983

Robin Venuti
Membership Coordinator, 1982–1985

Cloyce Wall
Designer/Preparator, 1987–

Phyllis Winston
Publication Sales, 1984–

Jo Ann Yandle
Preparator, 1984–1987

Interns

Judy Allen
Workshop Intern, 1987

Lauri Bachenheimer
Workshop Intern, 1985

Bruce Bendure
Intern, 1973

Trym Bergsmo
Workshop Intern, 1986

Claire Braude
Curatorial/Editorial Intern, 1985–1986

Lisa Frank
Intern, 1972

Mary Goodwin
Intern, 1978; 1979

Robert MacKimmie
Workshop Intern, 1983

Tory Read
Editorial Intern, 1984–1985

Leah Williams
Workshop Intern, 1984

Sylvia Wolf
Curatorial/Editorial Intern, 1986–1987

Volunteers

Brenda Arbogast
Volunteer, 1985–1986

John Breeden
Volunteer, 1983–

Patrick Brown
Volunteer, 1987–

Janet Dahle
Volunteer, 1980

Delores Kaller
Volunteer, 1976–1978

CARMEL EXHIBITIONS

The Gallery of The Friends of Photography is located in the Sunset Center in Carmel, California, and the Opening Exhibition was the organization's first official activity. In late 1969, a second gallery in Sunset Center was opened, allowing simultaneous exhibitions. In 1976, that room was reclaimed as office space, and all exhibitions were displayed in the main, more formal gallery.

Between 1967 and 1972, exhibitions were organized by an exhibition committee, headed by Wynn Bullock. After that time, except where guest curators are named, primary curatorial responsibility was held by the following: Peter Hunt Thompson, 1971–1974; Fred Parker, 1972–1973; Charles Desmarais, 1973–1974; Cheryl Douglas, 1974; Rodney C. Stuart, 1974–1976; James Enyeart, 1976–1977; James G. Alinder and David Featherstone, 1977–1982; David Featherstone, 1983–.

An asterisk (*) indicates a catalogue was produced, often as an issue of *Untitled*. See "Publications" section for details.

1967
June 23–July 30
Opening Exhibition: Ansel Adams, Wynn Bullock, Imogen Cunningham, Dorothea Lange, Brett Weston, Edward Weston, Minor White

August 4–September 4
W. Eugene Smith; Bruce Davidson

September 15–October 15
Eugène Atget

October 21–November 19
Pirkle Jones; Ruth Marion Baruch

November 24–December 31
Paul Strand

1968
January 5–February 4
Aaron Siskind

February 9–March 31
Student Exhibition: Institute of Design, Chicago and University of New Mexico, Albuquerque. From the

Institute of Design: Kenneth Biasco, Barry Burlison, Linda Connor, Barbara Crane, Antonio A. Fernandez, Steve Foster, Joseph Jachna, Merette Johansen, Brian Katz, Barry Koral, William Larson, Dan McCormack, James Newberry, Carla Romeike, Jack Wilgus, Geoff Winningham. From the University of New Mexico: Jim Alinder, Harold Jones, Cavalliere Ketchum, James Kraft, Frank Newlander, Eve Sonneman

April 5–May 17
John Brook

May 24–July 15
ASUC Studio, University of California, Berkeley: John Allen, Roswell Angier, Margo Baumgarten, John Blaustein, Dave Bohn, Charles Breth, Ron Chamberlain, Barry Gordon, Sara Hartley, Arnold Henderson, Steve Miller, Roger Minick, Margaretta Mitchell, Jerri Romm, Leonard Sussman, Walter Tschinkel

July 18–August 25
Trustees of The Friends of Photography: Ansel Adams, Wynn Bullock, Arthur Connell, William Current, Liliane DeCock, Edward C. Forsyth, William Garnett, Richard M. Garrod, Rosario Mazzeo, Nancy Newhall, Donald Ross, Geraldine Sharpe, William Webb, Al Weber, Brett Weston

August 29–October 4
Bernard Freemesser, Elmar Wefers, Alfred Monner, Gerald Robinson

October 9–November 17
Marie Cosindas; George Schumacher

November 22–January 5
Donald Ross

1969
January 10–February 16
Minor White

February 21–March 29
Wayne Gravning; Oliver Gagliani

April 4–May 11
Paul Caponigro

May 16–June 29
Geraldine Sharpe

July 3–August 10
Jerry Uelsmann

August 15–September 21
Judy Dater; Barbara Crane

September 26–November 2
Liliane DeCock: *A Rural Landscape*

November 8–December 14
Jack Welpott

December 19–January 25
Platinum Print Exhibition: Alvin Langdon Coburn, Imogen Cunningham, Peter Henry Emerson, Frederick H. Evans, Margrethe Mather, Paul Outerbridge, Alfred Stieglitz, Edward Weston

December 19–January 25
Friends of Photography Membership Show, Part One

1970
February 6–March 15
Friends of Photography Membership Show, Part Two

February 6–March 15
E. Florian Steiner

March 20–April 26
Three Man Exhibition: Merg Ross, Edward Putzar, Don Normark

May 5–May 25
Harry Callahan

May 29–August 2
Photographic Impressions of Monterey County: Ansel Adams, Morley Baer, Jeffrey Broome, Wynn Bullock, Robert Byers, Jack Cakebread, Steve Crouch, Joe Czarnecky, Liliane DeCock, Brooke Elgie, Edward C. Forsyth, Roger Fremier, Richard Garrod, Jeffrey Gholson, Henry Gilpin, John Hicks, Regina Hicks, Ron James, Steve James, Sue James, Jerry Lebeck, Peter McArther, Ted Orland, Marion Patterson, Camp Russell, Studley, Judy Todd, Stanley Truman, Marvin Wax, Al Weber, Brett Weston, Jim Ziegler

August 6–September 13
Todd Walker

September 18–October 25
Photographs from Ansel Adams' Personal Collection: Ruth Bernhard, Matthew Brady, Arnold Genthe, Johann Hagemeyer, Pirkle Jones, Charles Sheeler, Southworth and Hawes daguerotype, Edward Steichen, Alfred Stieglitz, Paul Strand, Brett Weston, Edward Weston, Minor White and others

October 31–December 5
Barbara Morgan

December 11–January 17
Ann Parker

1971
January 23–Febuary 28
Cavalliere Ketchum; Anne Noggle

March 6–April 11
Brett Weston

April 17–May 23
Syl Labrot; Michael Di Biase

May 29–July 11
Albert Renger-Patzsch

July 17–September 5
Members Exhibition

September 10–October 23
Wynn Bullock

September 10–October 23
Ten Top European Photographers, East and West: Edward Hartwig, Poland; Wladislaw Marynowicz, England; Miloslav Stibor, Czechoslovakia; Raimo Gareis, West Germany; Gunar Bine, USSR; Wally Hengel, Austria; Dimiter Sibirsky, Bulgaria; Lotar Neuman, Switzerland; Istvan Toth, Hungary; Eduardo Gageiro, Portugal

October 29–December 11
Roger Minick

December 17–January 29
Imogen Cunningham

1972
February 4–March 10
The Visual Dialogue Foundation*: Michael Bishop, Linda Connor, Ed Douglas, Judy Dater, Karl Folsom, Oliver Gagliani, Michael Harris, Harvey Himelfarb, Timo Tauno Panjunen, Leland Rice, Charles Roitz, Sue Roitz, Stephen Soltar, John Spence Weir, Jack Welpott, Don Worth

March 17–April 23
Richard M. Garrod; Henry Gilpin

April 28–June 4
Leland Rice; Jack Ward

June 10–July 16
Edward Weston: Part One

July 22–August 27
Edward Weston: Part Two

August 29–October 1
The Crowded Vacancy: Lewis Baltz, Anthony Hernandez, Terry Wild Originated by the University of California, Davis

September 2–October 8
Joan Murray; LeRoy Robbins

October 3–November 12
Richard Julian; Robert Routh

October 14–November 19
Dave Bohn: *Landscapes of the American Southwest*

November 14–December 31
Lewis Hine

November 25–December 31
Adam Clark Vroman

1973
January 6–January 28
Manual Alvarez Bravo

January 6–February 4
Paul Strand's *Mexican Portfolio*

February 3–March 11
One Hundred Photographs from the Pasadena Art Museum Collection:
Ansel Adams, Eugene Atget, Wynn Bullock, Imogen Cunningham, Frederick Sommer, Alfred Stieglitz, Paul Strand, Edward Weston, Minor White

March 28–April 29
Morley Baer

March 31–May 6
Aaron Siskind

May 9–June 10
Non-Silver Group Show: Darryl Curran, Stephen Josefsberg, Peggy Kerr, Rodger Hudson Klein, Ellen Land-Weber, John Lawrence, Brian Miller, Kay Shuper, Gayle Smalley, Robert von Sternberg, Arthur Taussig, Terry Thompson, Todd Walker
Guest Curator: Darryl Curran

May 12–June 10
Anthony Hernandez; Terry Wild

June 13–July 15
Robert Rauschenberg

June 19–July 22
André Kertész

July 18–August 19
Phil Palmer

July 28–August 26
Emmet Gowin

August 22–September 30
*3–M Color**: Tyler James Hoare, Ellen Land-Weber, Cheryl N. Leonard, Sonia Sheridan, Keith Smith and Arthur Taussig

September 1–October 6
Robert Heinecken

October 13–November 18
Brassai

October 3–November 18
Jacques Henri Lartique

November 24–December 30
National Juried Exhibition

1974
January 9–February 10
Edwin Janss

January 12–February 10
Takuya Tsukahara

February 13–March 31
Eugene Atget

February 23–March 31
Berenice Abbott

April 2–May 19
Bart Parker

April 6–May 19
Joseph Jachna

May 25–July 7
Marion Palfi

July 13–August 25
Charles Spink, Bernard Plossu, Kenneth Josephson

August 30–October 27
Polaroid Collection: Photographs:
Ansel Adams, Nubar Alexanian, John Benson, Paul Caponigro, Mark Cohen, Linda Connor, Nicholas Dean, Michael Di Biase, Walker Evans, Richard Faller, Henry Foley, Kathy Florsheim, Tyron Georgiou, Stephen Gersh, Frank Gohlke, Emmet Gowin, James Haberman, Robert Haiko, Peter Hunsberger, Robert Jonas, Yousuf Karsh, Daniel Kaufman, Robert Kollbrenner, Warren Kropsaw, Ron LaFon, Peter Laytin, Silvano Maggi, Robert Mapplethorpe, William W. Mercer, Mark Power, Rosamond Wolf Purcell, Susan Ross, Peter Schlessinger, Carl Sesto, Jean-Loup Sieff, Jeffrey Silverthorne, Phil Simmerman, Vincent Vallarino, Caroline Vaughan,

Ann Warrington, Stephen Whealton, Minor White, Donald Woodman, William Wray

November 9–December 8
Edmund Teske; Geoffrey Winningham

December 14–February 2
Henry Holmes Smith

1975
February 8–March 16
Eikoh Hosoe; Ken Graves

March 22–April 27
Ten Teachers of Creative Photography for the San Francisco Bay Area: Ruth Bernhard, Judy Dater, Oliver Gagliani, Josepha Haveman, Vilem Kriz, Joanne Leonard, Joan Murray, Timo Tauno Pajunen, John Spence Weir, Jack Welpott

March 22–April 27
History Transformed: History as Subject Matter: Michael Bishop, Bill Burke, Van Deren Coke, Linda Connor, Cotter, Darryl Curran, Robert Fichter, Harold Feinstein, David Firestone, Fitzwater, Charles Gill, Robert Heinecken, Victor Landweber, Leland Rice, Lew Thomas, Peter Hunt Thompson, John Upton, Mike Mandel, Arthur Taussig
Guest Curator: Arthur Taussig
Originated by Orange Coast College

May 2–June 8
David Bayles, Reni Graham, Mark Orlove, Alice Swan

June 13–July 27
Membership Show

August 1–September 7
Paul Caponigro; Abigail Heyman

September 12–October 19
Four San Francisco State University Graduates: Mark Citret, Ted Orland, Greg MacGregor, Hans Levi

October 24–December 7
Barbara Crane; Eva Rubinstein

December 13–January 26 *Brett Weston: Fifty Years*

1976
January 31–March 28
San Francisco Art Institute Students and Faculty: Joe Babcock, Harry Bowers, Ellen Brooks, Jerry Burchard, Steve Bye, Deborah Cloud, John Col-

lier, Linda Connor, Anne Cunney, Judy Dater, Jim Ferguson, Jack Fulton, Phillip Galgiani, John Gray, Barbara Greenberg, John Harding, Michael Jang, Pirkle Jones, Steve Josefsberg, Eric Lauritzen, George LeGrady, Joanne Leonard, Marcia Lieberman, Margery Mann, Ron McClure, Lynn Mueller, Tom Patton, Susie Reed, Ron Rowe, Allison Scott, Jay Sherman, Glenn Steiner, Charles Stephanian, Eric Sundance, John Swanda, Henry Wessels, Jr., Casey Williams

April 2–May 30
Classics of Documentary Photography: Werner Bishof, Robert Capa, David Seymour, Roman Vishniac, Dan Weiner
Originated by the International Center of Photography, New York

June 4–July 11
Arthur Lazar, Paul Hill, Tom Cooper

July 17–September 12
Members Exhibition

September 18–October 24
Marsha Burns, Michael Burns, Ron Lafon, Shedrich Williames, Ron Wohlauer

October 30–January 2
Emerging Los Angeles Photographers★: Gary Burns, Jo Ann Callis, Eileen Cowin, John Divola, Lou Brown DiGiulio, Jeff Gates, Judith Golden, Suda House, James Hutchinson, Steve Kahn, Victor Landweber, Ron Leighton, Philip Melnick, Virgil Marcus Mirano, Grant Rusk, Sherie Scheer, Elliot Schwartz, Kay Shuper, Ken Slosberg, Arthur Taussig

1977
January 15–February 20
New Portfolios★: Berenice Abbott, Ansel Adams, Morley Baer, George Krause, Stephen Shore, W. Eugene Smith, Paul Strand, Brett Weston, New Mexico Portfolio, Underware: A National Photography Portfolio
Originated by the Montgomery Art Gallery, Pomona College

February 25–April 3
Peter Hunt Thompson★

April 23–June 12
Norman Locks★

June 17–July 31
Lou Stoumen: Photographs 1934–1977★

August 6–September 4
Members Exhibition

September 9–October 30
Don Worth★

November 4–December 11
Jo Ann Frank, Sally Mann, Jorgen Skogh★

December 16–January 27
Ed del Valle and Mirta Gomez, Harold Jones, Sean Kernan★

1978
February 3–March 5
Tom Millea★

March 10–April 23
Bernard Freemesser: A Retrospective Exhibition★

April 28–May 28
Philip Trager

June 2–July 2
Arthur Tress

July 7–August 6
Members Exhibition

August 18–September 17
Jerome Liebling★

September 22–October 29
Ansel Adams: Fifty Years of Portraits★

November 3–December 10
Color Photographs: John Divola, Steve Fitch, Kenda North, Arthur Ollman, John Pfahl

December 15–January 15
The Photograph as Artifice: Ansel Adams, Lewis Baltz, Felix Bonfils, Wynn Bullock, Walter Drucker, Walker Evans, William Henry Jackson, Andre Kertesz, Timothy O'Sullivan, Paul Outerbridge, Jr., Timo Tauno Pajunen, Bart Parker, Leland Rice, Henry Peach Robinson, Edward Weston, several anonymous photographers
Curator: John Upton
Originated by California State University, Long Beach

1979
January 19–February 18
Francis J. Bruguière: A Retrospective Exhibition of His Photographs
Curator: James Enyeart

February 23–March 25
Robert Cumming★

March 28–April 29
Judy Dater; Wright Morris

May 4–June 3
Ken Baird, Lawrence McFarland, Olivia Parker

June 8–July 8
Vilem Kriz★

July 13–August 12
Members Exhibition

August 17–September 16
Mary Lloyd Estrin

September 21–October 21
Klaus Frahm, Gretchen Garner, Stephanie Torbert

October 26–November 25
Ruth Bernhard: A Retrospective Exhibition★

November 30–January 6
Michael Bishop
Originated by Chicago Center for Contemporary Photography at Columbia College

1980
January 11–February 10
Roy DeCarava★

February 15–March 16
Carleton E. Watkins: Photographs of the Columbia River and Oregon★

March 21–April 20
The Diana Show: Pictures Through a Plastic Lens★: Jim Alinder, Susan Backman, John Carnell, Larry S. Ferguson, Valorie Fisher, Brian Forrest, Sally Gall, Carson Graves, Gene Groppetti, Stephen M. Guenther, David Hamilton, John D. Hansen, Sindy Kipis, Gary Kolb, T.M. Langdon, Lili Lauritano, Dennis Letbetter, Eric Lindbloom, Carl Martin, Charles Marut, Keith Mayton, Dan McCormack, Jack Murphy, Ardine Nelson, David Nester, Jeffrey A. Newman, Dirk E. Park, Thomas J. Petit, Duane Powell, Peter Reiss, Nancy Rexroth, Rich Rollins, Victoria Lyon Ruzdic, James Sandall, Lauren Shaw, Cindy Sirko, Peter Stazione, Brian D. Taylor, Joanne Tracy, Robyn Wessner,

Sharon Wickham, Graydon Wood, Ann Zelle

April 25–May 25
William DeLappa, John Takami Morita, Marcia Resnick

June 30–July 6
William Garnett

July 11–August 10
Diane Keaton; Tricia Sample

August 15–September 14
Members Exhibition

September 19–October 19
Edmund Teske★

October 24–November 23
New Landscapes, Part One★: David Avison, Morley Baer, Winston Swift Boyer, Robert K. Byers, Walter Chappell, Mark Citret, Peter de Lory, King Dexter, Jay Dusard, Larry S. Ferguson, Neil Folberg, William Garnett, Richard Garrod, William Giles, Henry Gilpin, Lyle Gomes, Art Grice, Andrea Jennison, Michael Johnson, Pirkle Jones, Robert Glenn Ketchum, Stuart D. Klipper, Lynn Lown, Lawrence McFarland, Jim Needham, Edward Ranney, Charles Roitz, Alan Ross, John Sexton, Clinton Smith, Michael A. Smith, Mary Swisher, Mathias Van Hesemans, Laura Volkerding, Huntington Witherill, Don Worth

November 28–December 28
New Landscapes, Part Two★: Robert Adams, Laurie Brown, Stephen Berens, Linda Connor, Joe Deal, Robbert Flick, Deborah Flynn, Lee Friedlander, Frank Gohlke, Wanda Hammerbeck, Eric Johnson, Harold Jones, Mark Klett, Jean Locey, Martha Madigan, Susan Makov, Joe Maloney, Richard Margolis, Barbara Mensch, Tom Millea, Richard Misrach, Barbara Noah, Ted Orland, Bruce Patterson, John Pfahl, Tricia Sample, Gail Skoff, Jerry Uelsmann, Gwen Widmer

1981
January 16–March 1
John B. Greene

March 6–April 5
New Work: Paul Berger, Jerry Burchfield, Jo Ann Callis, Jan Groover, Robert Fichter, Richard Misrach, Patrick Nagatani, Barbara Jo Revelle, Ken White

April 10–May 10
John Pfahl★

May 15–June 14
Lawrie Brown, Martha Pearson Casanave, Susan Friedman

June 19–July 19
Olivia Parker

July 24–August 23
Ferguson Grant Recipients, 1972–1981: Jo Ann Callis, Susan Felter, Ken Graves, Anthony Hernandez, Joseph Jachna, Mark Klett, David Maclay, Sally Mann, Richard Misrach, Meridel Rubenstein

August 28–September 27
Larry S. Ferguson, Frank Gohlke, Roger Mertin

October 2–November 1
Marsha Burns★

November 6–December 6
Four French Photographers: Lucien Clergue, Jean Dieuzaide, Bernard Faucon, Martine Franck

December 11–January 10
Samuel Bourne★

1982
January 15–February 14
Thomas Barrow

February 19–April 11
The Unknown Ansel Adams★

April 16–May 23
Four Color Photographers: William Christenberry, Avery Danziger, Emmet Gowin, Terry Husebye

May 28–July 4
Members Exhibition

July 9–August 22
Brett Weston: New Work

August 27–September 26 Dyed Images: Recent Work in Dye Transfer: Carl Kurtz, Syl Labrot, Kenda North, John Pfahl, Eliot Porter, Susan Shaw, Henry Holmes Smith, Stan Smith, Charles Swedlund
Guest Curator: Ellen Manchester

October 1–November 14
Renate Ponsold/Robert Motherwell: Apropos Robinson Jeffers
Originated by California State University, Long Beach

November 19–January 2
The Contact Print★: Harry Callahan, Linda Connor, Emmet Gowin, Nicholas Nixon, Olivia Parker, Frederick Sommer, Michael A. Smith, Josef Sudek, Brett Weston, Minor White

1983
January 7–February 13
Segmentations: Christopher Burnett, Chuck Close, Robbert Flick, David Joyce, Ann Lovett, Robert Schiappaccasse, John Williams

February 18–April 13
Max Yavno: Recent Photographs from Mexico

April 8–May 8
John Stewart

May 13–June 19
Mount St. Helens: The Photographer's Response: Marilyn Bridges, Tod E. Gangler, Frank Gohlke, Emmet Gowin, Eve Sonneman, Joel Sternfeld, Mathias Van Hesemans, United States Geological Survey photographs

June 24–July 31
Beaumont Newhall, A Retrospective

August 5–September 9
Members Exhibition

September 16–October 23
Nicholas Nixon★

October 28–December 4
Dave Read

December 9–January 15
Mary Ellen Mark: Photographs from Mother Teresa's Missions of Charity, Calcutta★

1984
January 20–February 26
Kenneth Josephson

March 4–April 15
Masking/Unmasking: Aspects of Post-Modernist Photography: Eileen Cowin, Louise Lawler, Richard Prince, Cindy Sherman, Laurie Simmons, James Welling
Guest Curator: Andy Grundberg

April 27–May 13
Ansel Adams Memorial Exhibition★

May 18–June 10
Marion Post Wolcott: Farm Security Administration Photographs★

June 15–July 22
Point Lobos: Place as Icon: Ansel
Adams, Jim Alinder, Richard Arentz,
Morley Baer, Ruth-Marion Baruch,
Joseph W. Boudreau, Lawrie Brown,
Joan Ingoldsby Brown, Edna Bullock,
Wynn Bullock, Paul Caponigro, Imo-
gen Cunningham, George Fiske, Rich-
ard Garrod, Lana Cory Hall, Goodwin
Harding, C. W. Johnson, Pirkle Jones,
James M. Kasson, Jean Locey, Tom
Millea, Bea Nettles, Beaumont
Newhall, Ted Orland, Naomi Reddert,
Clara Sipprell, Keith Smith, W.
Eugene Smith, James D. Steele, Rob-
ert Stiegler, George E. Stone, Karen
M. Strom, Stephen E. Strom, Brian D.
Taylor, Jerry Uelsmann, Willard Van
Dyke, Sam Wang, Brett Weston, Cole
Weston, Edward Weston, Minor
White, Huntington Witherill, Don
Worth

July 27–September 2
Alfred Seiland; Joel Sternfeld

September 7–October 14
American Social Documents: Larry
Fink, Jim Goldberg, Barbara Norfleet

October 19–November 25 *Foreign
Views: Photographs by Linda Connor*

December 7–January 13
Richard Misrach: *A Decade of
Photography*

1985
January 18–February 24
*Todd Walker: A Retrospective**
Guest Curator: Julia Nelson-Gal

March 1–April 7
Heaven and Earth: Don Anton/Lewis
deSoto
Guest Curator: Tory Read

April 12–May 26
Doris Ulmann: American Portraits

June 1–July 14
*William Eggleston: Recent Color
Photographs*
Guest Curator: JoAnn Yandle

July 19–September 1
*The Carmel Project: New 20 x 24 Pola-
roid Photographs*: Lawrie Brown, Joel
Leivick, Catherine Wagner, Melanie
Walker, Don Worth
Guest Curator: Julia Nelson-Gal

September 6–October 13
*The Camera and the Environment:
Chris Rainier and David Stephenson*

October 18–December 1
*The Colored Image: Hand-Applied
Color in Photography*: Anne Barnard,
Gloria DeFilipps Brush, Allan Chasan-
off, Dennis Farber, Bayat Keerl, Kim
Mosley, Patrick Nagatani & Andrea
Tracey, Ted Orland, Dan Powell, John
Reuter, Holly Roberts, Linda Robben-
nolt, Gail Skoff, Evon Streetman,
Frank Thomson, Arthur Tress

December 6–January 12
Edouard-Denis Baldus

1986
January 17–February 26
*Portraits: Leon Borensztein, Michael
Disfarmer*
Guest Curator: Linda Bellon-Fisher

March 7–April 20
*Edward Weston: A Mature Vision**

April 25–June 1
Linda Robbennolt

June 6–July 13
*Johnny Alterman: Vertical Walkway
Huntington Witherill: Landscapes*

July 18–August 31
A Summer's Day: Joel Meyerowitz
Guest Curator: Claire Braude

September 5–October 12
*Illusive Scapes: Robert Johnson, Brian
Taylor*
Guest Curator: Linda Bellon-Fisher

October 17–November 30
*Mississippi Photographs:
Birney Imes III*

December 12–January 25
*A California Retrospective: Morley
Baer*

1987
January 30–March 15
Judith Golden: Recent Photographs

March 20–April 26
*You Never Know: Prints by Maria
Gonzalez*
Guest Curator: JoAnn Yandle

May 1–June 14
Alma Lavenson: *A Ninetieth Birthday
Retrospective*
Guest Curator: Susan Ehrens

June 19–August 9
*Twentieth Anniversary Exhibition, Part
One*: Ansel Adams, Eugène Atget,
Lewis Baltz, Wynn Bullock, Marie
Cosindas, Imogen Cunningham, Bruce
Davidson, Emmet Gowin, Robert Hei-
necken, Dorothea Lange, Barbara
Morgan, Aaron Siskind, Todd Walker,
Brett Weston, Edward Weston, Minor
White, Jerry Uelsmann
Co-curators: David Featherstone, Syl-
via Wolf

August 14–September 27
*Twentieth Anniversary Exhibition, Part
Two*: Ansel Adams, Samuel Bourne,
Marsha Burns, Robert Cumming, Roy
DeCarava, Jim Goldberg, Mary Ellen
Mark, Olivia Parker, John Pfahl,
Linda Robbennolt, Cindy Sherman,
Arthur Tress, Carleton Watkins, Brett
Weston, Don Worth.

October 9–November 29
*Narrative Images/Post-Documentary
Photography*: Carole Conde & Karl
Beveridge, Bonnie Donohue & Warner
Wada, Jeff Gates, Fred Lonidier
Guest Curator: Linda Bellon-Fisher

December 4–January 31
*Photography on the Monterey Penin-
sula: The New Generation*: Martha
Pearson Casanave, Tom Millea, Chris
Rainier, John Sexton, Jerry Takigawa,
Huntington Witherill.

TRAVELING
EXHIBITIONS

During the early 1970s, when the
growing interest in exhibitions of pho-
tographs was not supported by knowl-
edgable curatorial expertise in many
institutions, organizations such as The
Friends were looked to to provide qual-
ity exhibitions. In more recent years,
major exhibitions organized by The
Friends have been seen throughout the
world, bringing national and interna-
tional recognition.

Albert Renger-Patzsch

1971
May 29–July 11
The Friends of Photography

1974
March 20–April 15
A.S.A. Gallery, University of New Mexico, Albuquerque, New Mexico

June 3–June 29
Visual Arts Department, Columbia College, Chicago, Illinois

1976
January 19–February 16
The Photo Shoppe Gallery, Lubbock, Texas

March 1–March 26
Center for Creative Photography, University of Arizona, Tucson, Arizona

Edward Weston

1972
June 10–July 16
Part One, The Friends of Photography

July 22–August 27
Part Two, The Friends of Photography

1973
January 30–March 25
Pasadena Modern Art Museum, Pasadena

April 26–June 3
Minneapolis Institute of Arts, Minneapolis

June 25–July 23
Sheldon Art Gallery, University of Nebraska, Lincoln

August 6–September 3
Albrecht Gallery, St. Joseph, Missouri

September 15–November 1
San Antonio Museum of Art, San Antonio, Texas

1974
January 27–March 10
The Photo Shoppe Gallery, Lubbock, Texas

April 14–May 5
Museum of Fine Arts, St. Petersburg, Florida

July 15–September 1
University Art Museum, University of Texas, Austin

September 21–October 20
Henry Gallery, University of Washington, Seattle

November 8–December 8
Fort Lauderdale Museum of the Arts, Fort Lauderdale, Florida

Adam Clark Vroman

1972
November 25–December 31
The Friends of Photography

1973
November 20–December 30
Pasadena Modern Art Museum, Pasadena

1974
November 8–December 6
Pratt Institute, Brooklyn, New York

1976
January 5–January 31
G. Ray Hawkins Gallery, Los Angeles

Ansel Adams I

1973
January 30–March 25
Pasadena Modern Art Museum, Pasadena

April 19–May 20
Grand Rapids Art Museum, Grand Rapids, Michigan

June 4–June 30
Afterimage Gallery, Dallas, Texas

August 18–October 13
The Photo Shoppe Gallery, Lubbock, Texas

1974
March 15–April 14
Campus Art Gallery, Santa Rosa Junior College, Santa Rosa

October 2–October 27
Fresno Arts Center, Fresno

November 23–December 31
Grapestake Gallery, San Francisco

Ansel Adams II

1973
June 1–July 15
Edison Street Gallery, Salt Lake City

November 1–December 3
Kansas City, Missouri

1974
January 1–February 15
College Association for Public Events and Services, Fullerton Junior College, Fullerton

March 1–April 12
Art Department Gallery, University of Nebraska, Omaha

October 30–January 1
831 Gallery, Birmingham, Michigan

1975
April 1–May 5
Northwood Institute, Dallas

July 22–August 22
Mattie Silk's Gallery, Urbana, Illinois

September 10–September 29
Carleton College, Northfield, Minnesota

October 15–November 15
University of Tennessee at Chattanooga, Chattanooga

December 5–December 25
Grapestake Gallery, San Francisco

3–M Group Show

Tyler James Hoare, Ellen Land-Weber, Cheryl N. Leonard, Sonia Sheridan, Keith Smith, Arthur Taussig; curator: Cheryl Douglas

1973
August 22–September 30
The Friends of Photography

1974
January 26–March 24
Pasadena Modern Art Museum Pasadena

April 19–May 19
Addison Gallery of American Art, Phillips Academy, Andover, Massachusetts

September 1–September 30
University Art Museum, University of Texas, Austin

Polaroid Collection

Ansel Adams, Nubar Alexanian, John Benson, Paul Caponigro, Mark Cohen, Linda Connor, Nicholas Dean, Michael Di Biase, Walker Evans, Richard Faller, Henry Foley, Kathy Florsheim, Tyron Georgiou, Stephen Gersh, Frank Gohlke, Emmet Gowin, James Haberman, Robert Haiko, Peter Hunsberger, Robert Jonas, Yousuf Karsh, Daniel Kaufman, Robert Kollbrenner, Warren Kropsaw, Ron LaFon, Peter Laytin, Silvano Maggi, Robert Mapplethorpe, William W. Mercer, Mark Power, Rosamond Wolf Purcell, Susan Ross, Peter Schlessin-

ger, Carl Sesto, Jean-Loup Sieff, Jeffrey Silverthorne, Phil Simmerman, Vincent Vallarino, Caroline Vaughan, Ann Warrington, Stephen Whealton, Minor White, Donald Woodman, William Wray

1974
July 18–August 19
Elizabeth Holmes Fisher Art Gallery, University of Southern California, Los Angeles

August 30–October 27
The Friends of Photography

November 1–November 30
Minneapolis College of Art and Design, Minneapolis

Emerging Los Angeles Photographers

Gary Burns, Jo Ann Callis, Eileen Cowin, Lou Brown DiGiulio, John Divola, Jeff Gates, Judith Golden, Suda House, James Hutchinson, Steve Kahn, Victor Landweber, Ron Leighton, Philip Melnick, Virgil Marcus Mirano, Grant Rusk, Sherie Scheer, Elliot Schwartz, Kay Shuper, Ken Slosberg, Arthur Taussig; curator: Rodney C. Stuart

1976
October 30–January 2
The Friends of Photography

1977
February 10–March 13
International Center for Photography, New York, New York

Francis J. Bruguière: A Retrospective

Curator: James L. Enyeart

1977
November 19–July 8
Art Museum of Princeton, Princeton, New Jersey

1978
April 23–May 30
Center for Contemporary Photography, Tucson, Arizona

August 29–September 24
Oakland Museum, Oakland

October 16–November 12
Art Galleries, California State University, Long Beach

1979
January 19–February 18
The Friends of Photography

The Diana Show, Pictures Through a Plastic Lens

Jim Alinder, Susan Backman, John Carnell, Larry S. Ferguson, Valorie Fisher, Brian Forrest, Sally Gall, Carson Graves, Gene Groppetti, Stephen M. Guenther, David Hamilton, John D. Hansen, Sindy Kipis, Gary Kolb, T. M. Langdon, Lili Lauritano, Dennis Letbetter, Eric Lindbloom, Carl Martin, Charles Marut, Keith Mayton, Dan McCormack, Jack Murphy, Ardine Nelson, David Nester, Jeffrey A. Newman, Dirk E. Park, Thomas J. Petit, Duane Powell, Peter Reiss, Nancy Rexroth, Rich Rollins, Victoria Lyon Ruzdic, James Sandall, Lauren Shaw, Cindy Sirko, Peter Stazione, Brian D. Taylor, Joanne Tracy, Robyn Wessner, Sharon Wickham, Graydon Wood, Anne Zelle
Curator: David Featherstone

1980
March 21–April 20
The Friends of Photography

June 15–July 15
The Catskill Center for Photography, Woodstock, New York

September 15–October 15
University of Southern California Art Galleries, Los Angeles

October 28–November 29
San Francisco Camerawork, San Francisco

December 15–January 15
Massachusetts College of Art, Boston

1981
February 1–February 28
Ohio State University, Columbus

March 15–April 15
Center for the Visual Arts Gallery, Illinois State University, Normal

May 1–May 31
Southern Light Gallery, Amarillo College Photography Department, Amarillo, Texas

June 15–July 15
Gardiner Art Gallery, Oklahoma State University, Stillwater

August 1–August 31
The Colorado Photographic Arts Center, Denver

October 1–October 31
Central Washington State University, Ellensburg

Ansel Adams, Photographs of the American West

Curator: James G. Alinder (Circulated under the auspices of the United States International Communications Agency.)

1980
November 18–November 26
American Center, New Delhi, India

December 2–December 6
Department of Fine Arts, Punjab University, Chandigarh, India

December 17–December 20
Beldih Hall, Jamshedpur, India

December 26–January 2
American Center, Calcutta, India

1981
January 27–February 5
American Center, Madras, India

February 12–February 16
Faculty of Fine Arts, University of Baroda, Baroda, India

February 19–February 25
Jehangir Art Gallery, Bombay, India

March 15–April 15
Murabha Palace, Riyadh, Saudi Arabia

April 22–May 6
Jidda, Saudi Arabia

May 13–May 27
Dhahran, Saudi Arabia

June–July
Royal Art Center, Amman, Jordan

August–September
National Museum, Damascus, Syria

November 6–November 31
Centre d'Art Bivant, Tunis, Tunisia

1982
January-March
National Art Gallery, Rabat, Morocco (also shown in Casablanca and Fez)

April-May
Cairo, Egypt

June-August
Israeli Museum, Tel Aviv, Israel

September-November
American Center, Pretoria, South
Africa

The Unknown Ansel Adams /
8oth Birthday Retrospective

1982
February 19–April 11
The Friends of Photography
(*The Unknown Ansel Adams*; curator:
James G. Alinder)

February 20–April 3
Monterey Peninsula Museum of Art,
Monterey
(*Ansel Adams 8oth Birthday Retrospective*; curator: Mary Street Alinder)

April 16–September 15
California Academy of Science
San Francisco

1983
September 24–November 27
Denver Museum of Natural History
Denver

Dyed Images, Recent Work in
Dye Transfer

Carl Kurtz, Syl Labrot, Kenda North,
John Pfahl, Eliot Porter, Susan Shaw,
Henry Holmes Smith, Stan Smith,
Charles Swedlund; curator: Ellen Manchester (Circulated under the auspices
of the Art Museum Association, San
Francisco.)

1982
August 27–September 26
The Friends of Photography

1983
February 1–February 28
Redding Museum and Art Center,
Redding

April 7–May 1
Alaska State Museum, Juneau

May 7–May 31
Visual Arts Center of Alaska,
Anchorage

June 6–June 30
Alaska Arts Association, Fairbanks

September 1–September 30
Fort Lauderdale Museum of the Arts,
Fort Lauderdale, Florida

October 16–November 11
Charleston Heights Art Center, Las
Vegas, Nevada

December 1–December 30
El Paseo Museum of Art, El Paso,
Texas

1984
March 22–April 19
Virginia Poly Technic University,
Blacksburg, Virginia

August 10–September 10
Montgomery Museum of Art, Montgomery, Alabama

October 29–November 23
Polk County Heritage Gallery, Des
Moines, Iowa

Photographs by Ansel Adams

Curators: James G. and Mary Street
Alinder

1983
February 4–February 28
Shanghai Gallery, People's Exhibition
Hall, Shanghai, People's Republic of
China (In association with the city of
San Francisco Sister City Program)

March 5–March 31
National Museum of Art, Beijing,
People's Republic of China

June 10–June 22
Odakyu Store Art Gallery, Shinjuku,
Tokyo, Japan

July 22–August 8
Hong Kong Arts Centre, Hong Kong

1984
June 26–August 26
Museum of Photographic Arts, San
Diego

1986
April 11–June 30
Palazzo Fortuny, Venice, Italy

October 12–December 14
Museo Civico, Genoa, Italy

1987
May 23–August 29
Museum of Modern Art,
Haifa, Israel

PUBLICATIONS

Newsletters

1970–1972
Eight issues of a mimeographed newsletter were used as a means of communicating news about The Friends to its
membership.

January 1978–December 1986
*The Newsletter of The Friends of
Photography* (monthly)
Editor: James G. Alinder
Managing Editor: David Featherstone
(1982–1986)
Associate Editors: David Featherstone
(1978–1982); Claire Peeps (1982–
1984); Julia Nelson-Gal (1984–1985);
Linda Bellon-Fisher (1985–1986)

January 1987–
*re:view, Newsletter of The Friends of
Photography* (monthly)
Editor: David Featherstone
Managing Editor: Linda Bellon-Fisher

The *Untitled* Series

Initiated to bring information about
The Friends and the field to the membership, the early issues of Untitled
took on a magazine format. During the
late 1970s, this evolved to the present
format, in which each issue addresses a
specific artist or topic and the design is
tailored to the specific content. Each
issue of *Untitled* was sent to all members of record at the time of publication as a benefit of membership.
Individual titles have also been sold
through book stores, museum shops
and galleries.

1972
Untitled 1
26 pages; 10 reproductions
Editor: Fred R. Parker
Text: Dody W. Thompson, "Edward
Weston"
Photographs by Edward Weston

Untitled 2 & 3
96 pages (double issue); 23 reproductions; 81 illustrations
Editor: Fred R. Parker

Text: Editorial, "Something to Think About," "William Everson Reads his own Poetry." A. D. Coleman, "A Manifesto for Photographic Education." Lisa Frank, "Lee Friedlander in Carmel." Ralph Gibson, "Letter to an Imaginary Friend." Anita Parker, "The New Theater: Playing for Real." Fred R. Parker, "Creativity is Contagious." Peter Hunt Thompson, "Robert Ashley: Slow but Purposeful," "George Hitchcock on American Poetry." William Webb, "Adam Clark Vroman." Jeffrey Whitmore, "Beaumont Newhall and the Image Environment." Photographs by Benedict Fernandez, Lee Friedlander, Ralph Gibson, Jerry Uelsmann, Adam Clark Vroman, Edward Weston

1973
Untitled 4
24 pages; 18 reproductions
Editor: Fred R. Parker
Text: Editorial, "The Ferguson Grant Judging, 1973." Fred R. Parker, "Anthony Hernandez." Peter Hunt Thompson, "Joseph Jachna," "The Field of Photographic Grants."
Photographs by Anthony Hernandez, Joseph Jachna

Untitled 5
20 pages; 21 reproductions
Guest Editor: Peter Hunt Thompson
Text: Peter Hunt Thompson, "Introduction." Wynn Bullock, "Wynn Bullock." Joan Murray, "Two Artistic Giants: Kertész and Rauschenberg." Fred R. Parker, "Robert Heinecken." Photographs by Wynn Bullock, Robert Heinecken, André Kertész, Robert Rauschenberg

Untitled 6
28 pages; 15 reproductions
Guest Editor: Cheryl Douglas
Text: Robert W. Corrigan, "The Transformation of the Avant-Garde." Peter Hunt Thompson, "The Juried Exhibition." William Webb, "A Prolegomenon to the Creative Experience Workshop #3."
Photographs by Lawrie Brown, Lucinda Bunnen, Gay Burke, Dwight Caswell, David L. Hufford, Victor Landweber, Elaine Mayes, David Adams Pond-Smith, Luther Smith,

Claire Steinberg, T. G. Tarnowski, Linda Tenukas

1974
Untitled 7/8
On Change and Exchange
80 pages (double issue); 59 reproductions
Guest Editor: Peter Hunt Thompson
Text: Ansel Adams, "Change Relates (Presumably) to Progress." Dave Bohn, "I Had Never Waited for the Light." James Broughton, "The Brotherhood of Light: From 'Letters to a Young Filmmaker.'" Judy Dater and Jack Welpott, "A Collaboration." Robert Forth, "Change and Exchange: Some Notes on the Uses of Surplus." Ralph Gibson, "Nothing Is Known." Robert F. Heinecken, "I Am Involved in Learning To Perceive and Use Light." Andre Kertesz, "I Must Leave the Rhetorics to Others." Victor Landweber, "Left with a Riddle, Supplied with an Answer." Gary Metz, "Some Conditions That Affect the Production of a Picture." Aaron Siskind, "In 1943 and 1944 a Great Change Took Place." Wayne Thiebaud, "As Far as I'm Concerned, There Is Only One Study and That Is the Way in Which Things Relate to One Another." Jerry N. Uelsmann, "I Have Long Been Nourished by Enigma."
Photographs by Lewis Baltz, Dave Bohn, Imogen Cunningham, Judy Dater, Ralph Gibson, Victor Landweber, Naomi Savage, Jerry N. Uelsmann, Jack Welpott
Designer: Peter Hunt Thompson

1975
Untitled 9
In Time
28 pages; 20 reproductions
Editor: Peter Hunt Thompson
Text: Dr. Howard Becker, "Think Program: Synopsis of the Exhibition 'Designing Programs/Programming Designs.'" Karl Gerstner, "Art as Collective Action." Sonia Landy Sheridan, "Statement." Peter Hunt Thompson, "In Time."
Photographs by Thomas Barrow, Robert Heinecken, Tyler James Hoare, Ellen Land-Weber, William Larson, Cheryl Leonard, Sonia Sheridan, Keith Smith, H. Arthur Taussig
Designer: Peter Hunt Thompson

1976
Untitled 10
Nancy Newhall
44 pages; 15 reproductions
Editors: Beaumont Newhall, Peter Hunt Thompson
Text: Beaumont Newhall, "Introduction." Ansel Adams, "A Tribute to Nancy Newhall." Diana E. Edkins, "A Tribute to Nancy Newhall." Nancy Newhall, "Brassaï;" "Controversy and the Creative Concept;" "Anselography Excerpts."
Photographs by Ansel Adams, Brassaï, Henri Cartier-Bresson, Nancy Newhall, Alfred Stieglitz, Paul Strand, Brett Weston, Edward Weston, Minor White
Designer: Peter Hunt Thompson

Untitled 11
Emerging Los Angeles Photographers
48 pages; 20 reproductions
Editor: Rodney C. Stuart
Text: Darryl Curran, "Introduction." Robert Heinecken, "Introduction." Leland Rice, "Some Thoughts on Camera Art." John Upton, "Introduction."
Photographs by Gary Burns, Jo Ann Callis, Eileen Cowin, Lou Brown DiGiulio, John M. Divola, Jeff Gates, Judith Golden, James Hutchinson, Suda House, Steve Kahn, Victor Landweber, Ron Leighton, Philip Melnick, Virgil Marcus Mirano, Grant Rusk, Sherie Scheer, Elliot Schwartz, Kay Shuper, Ken Slosberg, Arthur Taussig
Designer: G. Dean Smith

1977
Untitled 12
68 pages; 28 reproductions
Editor: James Enyeart
Text: Albert Renger-Patzsch, "An Essay Toward the Classification of Photography." James Enyeart, "Albert Renger-Patzsch: 1897–1966." Henry Holmes Smith, "Picking Winners."
Photographs by Albert Renger-Patzsch, Henry Holmes Smith
Designers: James Enyeart and Peter A. Andersen

Untitled 13
Plants: Photographs by Don Worth
48 pages; 35 reproductions
Editor: James Enyeart

Text: David Featherstone, "Plants: Photographs by Don Worth." Jack Welpott, "Don Worth and the Leafy Realm."
Photographs by Don Worth
Designer: Peter A. Andersen

1978
Untitled 14
72 pages; 31 reproductions
Editor: James Alinder
Text: Robert Adams, "Good News." James G. Alinder, "An Interview with Susan Sontag." Gerry Badger, "On British Photography." Jack Welpott, "East is East, and West?"
Photographs by Robert Adams, L. M. Ambler, Gerry Badger, Robert Barry, Peter Brittin, Thor A. Johnson, Douglas Manchee, Timo T. Pajunen, Meridel Rubenstein, Paddy Summerfield, Homer Sykes, Peter Turner, Catherine F. Wagner, John Spence Weir, Jack Welpott
Designer: Peter A. Andersen

Untitled 15
Jerome Liebling: Photographs 1947–1977
56 pages; 36 reproductions
Editor: James G. Alinder
Text: Estelle Jussim, "The Photographs of Jerome Liebling: A Personal View."
Photographs by Jerome Liebling
Designer: Peter A. Andersen

Untitled 16
Ansel Adams: 50 Years of Portraits
56 pages; 26 reproductions
Editor: James G. Alinder
Text: James G. Alinder, "The Portraits of Ansel Adams," "A Conversation on Portraiture."
Photographs by Ansel Adams
Designer: Peter A. Andersen

1979
Untitled 17
Comparative Photography: A Century of Change in Egypt and Israel
56 pages; 46 reproductions
Editor: James G. Alinder
Text: Brian M. Fagan, "Introduction."
Photographs by Francis Frith, Jane Reese Williams
Designer: Peter A. Andersen

Untitled 18
Robert Cumming, Photographs
56 pages; 42 reproductions; 3 illustrations
Editor: James G. Alinder
Text: James G. Alinder, "The Photographs of Robert Cumming;" "An Interview with Robert Cumming."
Photographs by Robert Cumming
Designer: Peter A. Andersen

Untitled 19
Vilem Kriz, Photographs
56 pages; 41 reproductions
Editor: James G. Alinder
Text: David Featherstone, "Vilem Kriz, Surrealist."
Photographs by Vilem Kriz
Designer: Peter A. Andersen

Untitled 20
Collecting Light: The Photographs of Ruth Bernhard
56 pages; 40 reproductions
Editor: James G. Alinder
Text: James G. Alinder, "Collecting Light."
Photographs by Ruth Bernhard
Designer: Peter A. Andersen

1980
Untitled 21
The Diana Show, Pictures Through a Plastic Lens
56 pages; 43 reproductions
Editor: David Featherstone
Text: David Featherstone, "Pictures Through a Plastic Lens"
Photographs by Jim Alinder, Susan Backman, John Carnell, Larry S. Ferguson, Valorie Fisher, Brian Forrest, Sally Gall, Carson Graves, Gene Groppetti, Stephen M. Guenther, David Hamilton, John D. Hansen, Sindy Kipis, Gary Kolb, Tom Langdon, Lili Lauritano, Dennis Letbetter, Eric Lindbloom, Carl Martin, Charles Marut, Keith Mayton, Dan McCormack, Jack Murphy, Ardine Nelson, David Nester, Jeffrey A. Newman, Dirk E. Park, Thomas J. Petit, Duane Powell, Peter Reiss, Nancy Rexroth, Rich Rollins, Victoria Lyon Ruzdic, James Sandall, Lauren Shaw, Cindy Sirko, Peter Stazione, Brian D. Taylor, Joanne Tracy, Robyn Wessner, Sharon Wickham, Graydon Wood,

Ann Zelle
Designer: Peter A. Andersen

Untitled 22
Images from Within, The Photographs of Edmund Teske
88 pages; 55 reproductions; 10 illustrations
Editor: James G. Alinder
Text: Pamela Blackwell, "Chronology." Aron Goldberg, "Introduction."
Photographs by Edmund Teske
Designer: Peter A. Andersen

Untitled 23
9 Critics/9 Photographs
48 pages; 9 reproductions
Editor: James G. Alinder
Text: James G. Alinder, "Doorway, 1979: Olivia and Helen in Transition." Robert Baker, "All Our Love Mother: A Photograph by Eugene Richards." Thomas F. Barrow, "Learning from the Past." James D. Burns, "Untitled #45086." David Featherstone, "Night for Day." Candida Finkel, "The Painful Butterfly." Gary Metz, "Meditations on a Blue Photograph." Beaumont Newhall, "Proleek Dolman #2." John L. Ward, "Evon Streetman, Chattooga Fantasy, 1979."
Photographs by Eileen Berger, Marsha Burns, Paul Caponigro, Robert Fichter, Roger Mertin, Arthur Ollman, Olivia Parker, Eugene Richards, Evon Streetman
Designer: Peter A. Andersen

Untitled 24
New Landscapes
56 pages; 40 reproductions
Editor: James G. Alinder
Text: James G. Alinder, "Robert Adams;" "Laura Volkerding." David Featherstone, "Linda Connor;" "Jay Dusard;" "Eric Johnson." Mark Johnstone, "Landscape: Perceiving the Land as Image." Mary Virginia Swanson, "Gail Skoff;" "Lynn Lown;" "Wanda Hammerbeck."
Photographs by Robert Adams, Linda Connor, Jay Dusard, Wanda Hammerbeck, Eric Johnson, Lynn Lown, Gail Skoff, Laura Volkerding
Designer: Peter A. Andersen

1981
Untitled 25
Discovery and Recognition

56 pages; 34 reproductions
Editor: James G. Alinder
Text: James G. Alinder, "Introduction." Wright Morris, "Photographs, Images and Words." Anita Ventura Mozley, "Imogen Cunningham: Beginnings." Beaumont Newhall, "John B. Greene."
Photographs by Harry Callahan, Imogen Cunningham, Roy DeCarava, Lee Friedlander, William Garnett, John B. Greene, Diane Keaton, Mark Klett, Richard Misrach, Wright Morris, Dirk E. Park, Tricia Sample, Edmund Teske, Carleton E. Watkins
Designer: Peter A. Andersen

Untitled 26
Altered Landscapes, The Photographs of John Pfahl
56 pages; 46 reproductions; 2 illustrations
Editor: James G. Alinder
Text: Peter C. Bunnell, "Introduction."
Photographs by John Pfahl
Designer: Peter A. Andersen

Untitled 27
Roy DeCarava, Photographs
192 pages (double issue); 82 reproductions
Editor: James G. Alinder
Text: James G. Alinder, "Preface." Sherry Turner DeCarava, "Celebration."
Photographs by Roy DeCarava
Designer: Peter A. Andersen

1982
Untitled 28
Postures: The Studio Photographs of Marsha Burns
48 pages; 41 reproductions
Editor: James G. Alinder
Managing Editor: David Featherstone
Text: David Featherstone, "Introduction."
Photographs by Marsha Burns
Designer: Peter A. Andersen

Untitled 29
Wright Morris, Photographs & Words
120 pages (double issue); 61 reproductions; 3 illustrations
Editor: James G. Alinder
Text: James G. Alinder, "Introduction." Wright Morris, "Photography in My Life."

Photographs by Wright Morris
Designer: Peter A. Andersen

Untitled 30
The Contact Print
48 pages; 38 reproductions
Editor: James G. Alinder
Text: James G. Alinder, "Introduction."
Photographs by Harry Callahan, Linda Connor, Emmet Gowin, Nicholas Nixon, Olivia Parker, Michael A. Smith, Frederick Sommer, Josef Sudek, Brett Weston, Minor White
Designer: Peter A. Andersen

1983
Untitled 31
Nicholas Nixon: Photographs from One Year
48 pages; 40 reproductions
Editor: James G. Alinder
Managing Editor: David Featherstone
Text: Robert Adams, "Introduction." James G. Alinder, "Preface." David A. Ross, "Foreword."
Photographs by Nicholas Nixon
Designer: Peter A. Andersen

Untitled 32
Mario Giacomelli
48 pages; 40 reproductions; 1 illustration
Editor: James G. Alinder
Managing Editor: David Featherstone
Text: Stephen Brigidi and Claire V. C. Peeps, "Introduction."
Photographs by Mario Giacomelli
Designer: Peter A. Andersen

Untitled 33
Samuel Bourne, Images of India
48 pages; 26 reproductions; 6 illustrations
Editor: James G. Alinder
Managing Editor: David Featherstone
Text: Arthur Ollman.
Photographs by Samuel Bourne
Designer: Peter A. Andersen

1984
Untitled 34
Marion Post Wolcott, FSA Photographs
48 pages; 35 reproductions; 4 illustrations
Editor: James G. Alinder
Managing Editor: David Featherstone
Text: Sally Stein, "Introduction."
Photographs by Marion Post Wolcott
Designer: Peter A. Andersen

Untitled 35
Observations, Essays on Documentary Photography
120 pages (double issue); 19 reproductions
Editor: David Featherstone
Text: David Featherstone, "Preface." Maria Morris Hambourg, "Atget, Precursor of Modern Documentary Photography." Bill Jay, "The Photographer as Aggressor." William S. Johnson, "Public Statements/Private Views: Shifting the Ground in the 1950s." Mark Johnstone, "The Photographs of Larry Burrows, Human Qualities in a Document." Estelle Jussim, "Propaganda and Persuasion." Max Kozloff, "A Way of Seeing and the Act of Touching: Helen Levitt's Photographs of the Forties." Beaumont Newhall, "A Backward Glance at Documentary." Alan Trachtenberg, "Walker Evans' America: A Documentary Invention." Anne Wilkes Tucker, "Photographic Facts and Thirties America."
Photographs by Eugene Atget, Larry Burrows, Walker Evans, Dorothea Lange, Russell Lee, Helen Levitt, Marion Post Wolcott
Designer: Peter A. Andersen

Untitled 36
Harry Callahan: Eleanor
Published in association with Callaway Editions
64 pages; 59 reproductions
Editor: Nicholas Callaway and Anne Kennedy
Managing Editor: David Featherstone
Text: James G. Alinder, "Harry and Eleanor."
Photographs by Harry Callahan
Designers: Nicholas Callaway and Anne Kennedy

Untitled 37
Ansel Adams, 1902–1984
56 pages; 12 reproductions; 30 illustrations
Editor: James G. Alinder
Text: James G. Alinder, "Introduction;" "Ansel Adams: A Chronology." Mary Alinder, "Ansel's Last Day." Peter C. Bunnell, "An Ascendant Vision." Alan Cranston, "A Legacy of Art and Action." Alfred Glass, "The Man of Many Facets." Rosario Mazzeo, "A Sense of Tone." Anita Ventura

Mozley, "In the High Sierra." Beaumont Newhall, "Ansel Adams: Friend of Photography." Wallace Stegner, "Miraculous Instants of Light." John Szarkowski, "Kaweah Gap and its Variants." Anne Wilkes Tucker, "The Lively Debate." William A. Turnage, "The Environmental Advocate."
Photographs by Ansel Adams
Designer: Peter A. Andersen

1985
Untitled 38
Todd Walker, Photographs
48 pages; 35 reproductions
Editor: James G. Alinder
Managing Editor: Julia Nelson-Gal
Text: Julia Nelson-Gal, "Introduction."
Photographs by Todd Walker
Designers: Todd Walker and Rebecca Gaver

Untitled 39
Mary Ellen Mark: Photographs of Mother Teresa's Missions of Charity in Calcutta
48 pages; 37 reproductions
Editor: James G. Alinder
Managing Editor: David Featherstone
Text: David Featherstone, "Introduction."
Photographs by Mary Ellen Mark
Designer: Desne Border

Untitled 40
Don Worth, Photographs 1955–1985
80 pages; 34 reproductions
Editor: James G. Alinder
Managing Editor: David Featherstone
Text: Hal Fischer, "The Exact and the Vast: Notes on an American Photographer."
Photographs by Don Worth
Designer: Desne Border

1986
Untitled 41
EW 100: Centennial Essays in Honor of Edward Weston
144 pages (double issue); 15 reproductions; 33 illustrations
Editors: Peter C. Bunnell and David Featherstone
Text: Peter C. Bunnell, "Introduction." Robert Adams, "The Achievement of Edward Weston: The Biography I'd Like To Read." Amy Conger, "Tina Modotti and Edward Weston: A Re-evaluation of their Pho-

tography." Andy Grundberg, "Edward Weston's Late Landscapes." Therese Thau Heyman, "Carmel: Beneficial to Bohemia." Estelle Jussim, "Quintessences: Edward Weston's Search for Meaning." Alan Trachtenberg, "Edward Weston's America: The 'Leaves of Grass' Project." Paul Vanderbilt, "No Magic Without Majesty." Mike Weaver, "Curves of Art." Charis Wilson, "The Weston Eye."
Photographs by Morley Baer, Arnold Genthe, Tina Modotti, Jane Reece, Roger Sturtevant, Edward Weston
Designer: Desne Border

Untitled 42
Eikoh Hosoe
68 pages; 35 reproductions; 3 illustrations
Editor: James G. Alinder
Managing Editor: David Featherstone
Text: Ronald J. Hill, "Afterword."
Photographs by Eikoh Hosoe
Designer: Desne Border

Other Books

The following books were produced by The Friends and distributed through general retail outlets. In some cases, they are hardcover editions otherwise identical to the softcover issues of *Untitled*.

1978
Self-Portrayal
116 pages; 101 reproductions
Editor: James G. Alinder
Text: Dana Asbury, "Photographing the Interior: The Self-Portrait as Introspection." Peter Hunt Thompson, "Self-Portrayal." R. Duncan Wallace, M.D., "On Self-Portrayal."
Photographs by Ansel Adams, Karen Anderson, Dana Asbury, R. Valentine Atkinson, Thomas F. Barrow, Gay Block, Carroll Parrott Blue, Bill Brandt, Brassaï, Manuel Alvarez Bravo, Cynthia Cable, Harry Callahan, Kerry T. Campbell, Bobbi Carrey, Lucien Clergue, Joyce Tenneson Cohen, Van Deren Coke, Joyce Culver, Darryl J. Curran, Robert Dawson, Peter Delory, William Di Biase, Elsa Dorfman, Tom Dugan, Allen A. Dutton, Scott D. Engel, Chris Enos, Reed Estabrook, Terry Evans, Penny Feinberg, Larry S. Ferguson, Elaine

Fisher, Abe Frajndlich, Lee Friedlander, Susan Friedman, Jane Tuckerman Foley, Jeff Gates, Ralph Gibson, Judith Golden, Don Gruber, Andre Haluska, Robert Heinecken, Jim Hill, Cheri Hiser, Eikoh Hosoe, Sandy Hume, Richard R. Hutter, De Ann Jennings, Kenneth Josephson, Colleen Kenyon, Andre Kertesz, Mark Krastof, Lynn Lennon, David S. Maclay, Michaelin McDermott, Duane Michals, Arno Rafael Minkkinen, Craig Morey, Ka Morais, Wright Morris, Kat Moser, John William Nagel, Jeffrey A. Newman, Anne Noggle, Sandra Y. Oguro, Suzanne Opton, Ted Orland, Joe Phillips, Michael K. Puig, Isabelle E. Purden, Marcia Resnick, Helen Richardson/Robert Schiappacasse, Noel K. Rubaloff, James Sandall, Barry Savenor, Bonnie F. Schenkenberg, E. A. Sedillos, Eva Seid, Sandra Semchuk, Lauren Shaw, Jasmine Shigemura, Kenneth Shorr, W. Eugene Smith, Alice Steinhardt, Frances E. Story, Sarah Tamor, Barbara Thompson, Peter Hunt Thompson, Arthur Tress, Linda Troeller, Jennifer Tucker, Mark Tuttle, Jerry Uelsmann, Todd Walker, Bruce Wallin, Isabel Waters, Brett Weston, Linda Szabo White, Gwen Widmer, Harry Wilson, Wallace Wong
Designer: Peter A. Andersen

1979
Carleton E. Watkins, Photographs of the Columbia River and Oregon
Published in association with the Weston Gallery, Carmel
136 pages; 51 reproductions; 3 illustrations
Editor: James G. Alinder
Text: James G. Alinder, "Preface." David Featherstone, "Carleton E. Watkins, The Columbia River and Oregon Expedition." Russ Anderson, "Watkins on the Columbia River, An Ascendency of Abstraction."
Photographs by Carleton E. Watkins
Designer: Peter A. Andersen

1980
Heinecken
Published in association with Light Gallery, New York City
160 pages; 92 reproductions
Editor: James Enyeart
Text: William Jenkins, "Introduction."

James Enyeart, "Preface." Marvin Bell, "To Heinecken the Photographer." Carl Chiarenza, excerpt from an unpublished article. Candida Finkel, "Space-Time and the Syzygy." Charles Hagan, adaptation from *Afterimage* interview with Heinecken, April 1976. Robert Heinecken, excerpt from *Photography Source and Resource*; excerpt from *Untitled 7/8*; adaptation from lecture at the Center for Creative Photography, January 28, 1976. John Upton, "Photograph As Object."
Photographs by Robert Heinecken
Designer: Peter A. Andersen

1981
Roy DeCarava, Photographs
192 pages (double issue); 82 reproductions
Editor: James G. Alinder
Text: James G. Alinder, "Preface." Sherry Turner DeCarava, "Celebration."
Photographs by Roy DeCarava
Designer: Peter A. Andersen

1982
Wright Morris, Photographs & Words
120 pages (double issue); 61 reproductions; 3 illustrations
Editor: James G. Alinder
Text: James G. Alinder, "Introduction." Wright Morris, "Photography in My Life."
Photographs by Wright Morris
Designer: Peter A. Andersen

1983
Overexposure: Health Hazards In Photography
329 pages
Author: Susan Shaw
Editor: David Featherstone
Designer: Peter A. Andersen

Exhibition Catalogues and Brochures

1973
3M Color
Exhibition Catalogue
30 pages; 12 reproductions; 2 illustrations
Editor: Cheryl Douglas
Text: Darryl Curran, "Introduction to the Exhibition." Douglas H. Dybvig, Thomas J. Evensen, John W. Ulseth, "The Color-In-Color Machine." Sonia

Sheridan, "Breaking Barriers with Copy Machines."
Photographs by Tyler James Hoare, Ellen E. Land-Weber, Cheryl N. Leonard, Sonia Sheridan, Keith Smith, Arthur Taussig

1976
New Portfolios
Exhibition Catalogue
Exhibition presented in conjunction with Pamona College
24 pages; 9 reproductions
Text: Leland Rice, "Introduction."
Photographs by Berenice Abbott, Ansel Adams, George Krause, Stephen Shore, W. Eugene Smith, Paul Strand, Brett Weston, New Mexico Portfolio, Underware: A National Photography Portfolio

1977
Peter Hunt Thompson
Exhibition Brochure
10 pages; 13 reproductions
Text: James Enyeart; Peter Hunt Thompson
Photographs by Peter Hunt Thompson

Norman Locks
Exhibition Brochure
4 pages; 10 reproductions
Photographs by Norman Locks

Lou Stoumen: Photographs 1934–1977
Exhibition Catalogue
Exhibition presented in conjunction with The Witkin Gallery, New York
12 pages; 17 reproductions
Text: James L. Enyeart, "Lou Stoumen: Photographs 1934–1977."
Photographs by Lou Stoumen

Jo Ann Frank, Sally Mann, Jörgen Skogh
Exhibition Brochure
4 pages; 3 reproductions
Photographs by Jo Ann Frank, Sally Mann, Jörgen Skogh

Ed del Valle and Mirta Gomez, Harold Jones, Sean Kernan
Exhibition Brochure
4 pages; 3 reproductions
Photographs by Ed del Valle and Mirta Gomez, Harold Jones, Sean Kernan

1978
Tom Millea
Exhibition Brochure
4 pages; 3 reproductions
Photographs by Tom Millea

Bernard Freemesser
Exhibition Catalogue
16 pages; 7 reproductions; 5 illustrations
Editor: David Featherstone
Text: George Beltran, "Freemesser Workshops." David Featherstone, "Bernard Freemesser—Photographer." George Craven, "Freemesser and the S.P.E." Gerald Robinson, "Bernie Freemesser—Friend."
Photographs by Bernard Freemesser
Designer: Peter A. Andersen

1980
Ansel Adams, Photographs of the American West
Published for the United States Information Agency in English, French and Arabic editions.
24 pages; 9 reproductions; 2 illustrations
Editor: James G. Alinder
Text: James G. Alinder, "Ansel Adams: A Retrospective View;" "Photographs: Ansel Adams."
Photographs by Ansel Adams
Designer: Peter A. Andersen

1982
The Unknown Ansel Adams
16 pages; 10 reproductions
Editor: James G. Alinder
Text: James G. Alinder, "Introduction." Ansel Adams, "A Personal Credo, 1982."
Photographs by Ansel Adams
Designer: Peter A. Andersen

Portfolios

These portfolios of reproductions, printed on high quality paper, were distributed to members as a benefit of membership.

1969
Portfolio I: *The Persistence of Beauty*
4 pages; 12 reproductions
Text: Nancy Newhall, "Introduction."
Photographs by Ansel Adams, Bill Brandt, Wynn Bullock, Harry Callahan, Henri Cartier-Bresson, Imogen Cunningham, Aaron Siskind, W. Eugene Smith, Paul Strand, Frederick Sommer, Brett Weston, Minor White

1970
Portfolio II: *Discovery: Inner and Outer Worlds*

4 pages; 15 reproductions
Text: Wynn Bullock, "Discovery: Inner and Outer Worlds"
Photographs by Dave Bohn, John Brook, Reva Brooks, Paul Caponigro, Marie Cosindas, Judy Dater, Liliane DeCock, Ray K. Metzker, Roger Minick, Gordon Parks, Edward Putzar, Geraldine Sharpe, E. Florian Steiner, Jerry N. Uelsmann, Todd Walker

Posters

1986
Photograph by Don Worth, produced as a Collectors Print Program membership benefit.

1987
Photograph by Joel Meyerowitz, produced as a Collectors Print Program membership benefit.

WORKSHOPS

Educational workshops have been an important program of The Friends throughout its history. Since the late 1960s, as more and more institutions began to offer workshops, The Friends' offerings have evolved in format, scope and content to meet the changing needs of the students. Unless otherwise designated, all workshops were held in California, primarily at various locations on the Monterey Peninsula.

1967
September 16–17
Monterey Workshop
Monterey Peninsula College, Monterey
Faculty: Ansel Adams, Brett Weston, others

1969
April 1–5
Easter Workshop
Monterey Peninsula College, Monterey
Faculty: Ansel Adams, Wynn Bullock, Henry Gilpin, Harold Jones, Al Weber

August 1–3
Mill Valley
Faculty: Ruth-Marion Baruch, Pirkle Jones

August 15–17
Mill Valley
Faculty: Ruth-Marion Baruch, Pirkle Jones

1970
March 27–April 4
Easter Workshop
Sunset Center, Carmel
Faculty: Ansel Adams, Morley Baer, Wynn Bullock, Steve Crouch, Glen Wessels, Brett Weston

July 13–25
Images and Words: The Making of a Photographic Book
Santa Cruz
Faculty: Ansel Adams, Pirkle Jones, Beaumont Newhall, Nancy Newhall, Adrian Wilson

September 13–19
Tioga Pass Resort, High Sierra
Faculty: Pirkle Jones, Wally MacGalliard, Ralph Putzker, Al Weber

September 20–27
Tioga Pass Resort, High Sierra
Faculty: Pirkle Jones, Wally MacGalliard, Al Weber, Glen Wessels

1971
April 6–10
Easter Workshop
Sunset Center, Carmel
Faculty: Ansel Adams, Dorr Bothwell, Imogen Cunningham, Liliane DeCock, Richard Garrod

1972
March 27–April 1
Easter Workshop
Sunset Center, Carmel
Faculty: Ansel Adams, Morley Baer, Wynn Bullock, Steve Crouch, William Garnett, Richard Garrod, Al Weber, Glen Wessels, Brett Weston

July 22–23
Lee Friedlander Workshop
Sunset Center, Carmel
Faculty: Lee Friedlander

July 29–30
Lee Friedlander Workshop
San Francisco Art Institute, San Francisco
Faculty: Lee Friedlander

August 14–25
Creative Experience Workshop
Sunset Center, Carmel

Faculty: Morley Baer, James Broughton, John Collier, Jr., Richard Conrat, Henry Geiger, Bernard Kester, Margery Mann, Ralph Putzker, Henry Holmes Smith, Wayne Thiebaud, Jerry Uelsmann, Jack Welpott (Proceedings detailed in *Untitled 2/3*)

1973
April 16–21
Easter Workshop
Hidden Valley Institute, Carmel Valley
Faculty: Morley Baer, Dave Bohn, Wynn Bullock, Steve Crouch, Darryl Curran, Margo Davis, Richard Garrod, Shirley Fisher, Wally MacGalliard, Fred Parker, Ralph Putzker, William Webb, Al Weber, Brett Weston

July 18–29
Creative Experience Workshop
Hidden Valley Institute, Carmel Valley
Faculty: Ansel Adams, Bill Arnold, Morley Baer, Brassaï, Wynn Bullock, Dr. Robert Corrigan, Steve Crouch, Darryl Curran, Judy Dater, Robert Forth, Richard Garrod, Dr. Harvey Gross, Ann Halprin, Lloyd Hamrol, Robert Heinecken, Andre Kertesz, Ellen Land-Weber, Elaine Mayes, Michael McClure, Eudora Moore, Xavier Nash, Robert Nelson, Beaumont Newhall, Nancy Newhall, Fred Parker, Peter Plagens, Dr. Ralph Putzker, David Reck, Dr. Albert E. Schlefen, Dr. Malcolm Seagrave, The New Theatre, Peter Thompson, Jerry Uelsmann, William Webb, Al Weber, Jack Welpott, Brett Weston, Minor White, Kerwin Whitnah

1974
January 28–29
Seminar on Teaching Photography
Pasadena
Faculty: Peter Bunnell

March 30–31
Exploring the Origins of Inspiration and the Creation of Visual Phrases
Sunset Center, Carmel
Faculty: Ralph Gibson

April 8–13
Easter Workshop
Sunset Center, Carmel
Faculty: Ansel Adams, Morley Baer, Wynn Bullock, Linda Connor, Steve Crouch, Ralph Gibson, Arthur Hall,

Jim Hill, Arthur Taussig, William Webb, Al Weber, Brett Weston

August 12–23
Creative Experience Workshop
Sunset Center, Carmel
Faculty: Ansel Adams, Casey Allen, Wynn Bullock, Lucien Clergue, Linda Connor, Judy Dater, William Everson, Robert Forth, Oliver Gagliani, Robert Heinecken, Allan Kaprow, Lisette Model, The New Theater, Bill Owens, Edmund Teske, Anne Tucker, Jerry Uelsmann, Jack Welpott

1975
February 15
Equivalents
Grapestake Gallery, San Francisco
Faculty: Walter Chappell

March 1
Co-sponsored by Monterey Peninsula College
Monterey
Faculty: Arnold Newman

March 24–29
Easter Workshop: Practical Aesthetics
Sunset Center, Carmel
Faculty: Ansel Adams, Morley Baer, Dave Bohn, Wynn Bullock, Walter Chappell, Bernard Freemesser, Oliver Gagliani, Richard Garrod, Henry Gilpin, Jim Hill, Anita Mozley, Bill Owens, Henry Holmes Smith, John Upton

April 12
The Nature of Exhibitions
Newport School of Photography, Newport Beach
Faculty: Harold Jones

June 13–15
Color Experience Workshop
Sunset Center, Carmel
Faculty: Steve Crouch, M. Halberstadt, Ralph Putzker, Al Weber, Glen Wessels

August 1–3
Members Workshop
Sunset Center, Carmel
Faculty: Morley Baer, Wynn Bullock, Robert Byers, Steve Crouch, Art Hall, Dave Kerr, Tom Millea, Hans Levi, Greg MacGregor, Ralph Putzker, Alan Ross, Michael Smith, Peter Hunt Thompson, Al Weber, Glen Wessels, Brett Weston

September 13
Informal Discussion: Artists Work and Philosophy
Garrapata Beach, Carmel
Faculty: Morley Baer, Mark Citret, Hans Levi, Greg MacGregor, Ted Orland

December 13
Brett Weston Workshop
Sunset Center, Carmel
Faculty: Morley Baer, Robert Byers, Richard Garrod, Brett Weston

1976
February 28–March 5
Zone System and Darkroom Technique
Yosemite National Park
Faculty: Oliver Gagliani, Norman Locks

March 27
A Survey of Contemporary Los Angeles Photography
Tacoma, Washington
Faculty: Leland Rice

April 10
What Is Vision and Where Does It Come From?
Los Angeles
Faculty: Neil Slavin

April 10–17
Easter Workshop
Sunset Center, Carmel
Faculty: Ansel Adams, Morley Baer, Dave Bohn, Linda Connor, Richard Garrod, Robert Heinecken, Norman Locks, Brett Weston, Cole Weston

May 22–28
California Institute of the Arts
Los Angeles
Faculty: Ralph Gibson, Norman Locks, Duane Michals

July 3–10
San Francisco Workshop
San Francisco Art Institute, San Francisco
Faculty: Lewis Baltz, Norman Locks, W. Eugene Smith, John Upton

July 16–18
Members Workshop
Sunset Center, Carmel
Faculty: Morley Baer, Robert Byers, Margo Davis, Shirley Fisher, Edward C. Forsyth, Oliver Gagliani, Richard Garrod, Henry Gilpin, Art Hall, Lester Henderson, Jim Hill, Steve James,

John Lamkin, Joanne Leonard, Hans Levi, Gary Lundberg, Greg MacGregor, Tom Millea, Richard Misrach, Frederick Mitchell, Joan Murray, Ralph Putzker, Alan Ross, Al Weber, Glen Wessels, Brett Weston, Cole Weston

July 31–August 7
Asilomar Workshop
Asilomar Conference Center, Pacific Grove
Faculty: Ansel Adams, David Bayles, Robert Heinecken, Ellen Land-Weber, Norman Locks, Arnold Newman, Bill Owens

October 2–9
Tucson Workshop
University of Arizona, Tucson, Arizona
Faculty: Paul Caponigro, Harold Jones, Norman Locks, Anne Noggle, Henry Holmes Smith

1977
March 14–20
Orcas Island Workshop
Orcas Island, Washington
Faculty: Arthur Bacon, Morley Baer, Dave Bohn, Al Weber

April 4–9
Easter Workshop
Sunset Center, Carmel
Faculty: Ansel Adams, Morley Baer, Dave Bohn, Tom Millea, Ted Orland, Al Weber, Brett Weston, Cole Weston

May 29–June 5
Tucson Workshop, co-sponsored by Center for Creative Photography
Tucson, Arizona
Faculty: Emmet Gowin, Ellen Land-Weber, Norman Locks, Duane Michals, Arnold Newman, George Tice

July 8–15
Asilomar Workshop
Asilomar Conference Center, Pacific Grove
Faculty: Ansel Adams, Lewis Baltz, Eikoh Hosoe, Norman Locks, Bea Nettles, Jerry Uelsmann, Al Weber

August 5–7
Members Workshop
Sunset Center, Carmel
Faculty: Morley Baer, Robert Baker, Robert Byers, Martin Dain, M. Halberstadt, Art Hall, Jim Hill, Tom King, Ellen Land-Weber, Norman

Locks, Dick McGraw, Greg Mac-
Gregor, Tom Millea, Ted Orland,
Ralph Putzker, Alan Ross, Paul
Schranz, Helen Wallis, Al Weber, Cole
Weston

1978

February 3–March 5
Governor's State University Workshop
Park Forest South, Illinois
Faculty: Morley Baer, Bill Owens, Al
Weber

March 3–8
Orcas Island Workshop
Orcas Island, Washington
Faculty: Arthur Bacon, Morley Baer,
Dave Bohn, Al Weber

March 20–25
Easter Workshop
Sunset Center, Carmel
Faculty: Ansel Adams, Morley Baer,
Robert Heinecken, Richard Misrach,
Ted Orland, Eva Rubinstein, Henry
Holmes Smith, Jerry Uelsmann, Al
Weber

June 23–29
Asilomar Workshop
Asilomar Conference Center, Pacific
Grove
Faculty: Ansel Adams, Van Deren
Coke, Barbara Crane, Ralph Gibson,
Betty Hahn, Edmund Teske, Al Weber

August 1–4
High School Photography Teachers
Workshop
Asilomar Conference Center, Pacific
Grove
Faculty: Robert Routh

August 4–6
Members Workshop
Sunset Center, Carmel
Faculty: Morley Baer, Robert Byers,
Martha Pearson Casanave, Richard
Garrod, Henry Gilpin, Art Hall, Wally
MacGalliard, Tom Millea, Ted Orland,
Ralph Putzker, Alan Ross, Michael
Sheras, Lou Stoumen, Cole Weston

August 7–9
Carmel Workshop
Sunset Center, Carmel
Faculty: Judith Golden, Tom Millea

1979

March 25–28
Photographing the Nude

Sunset Center, Carmel
Faculty: Judy Dater

March 28–31
Photographs and Words
Sunset Center, Carmel
Faculty: Wright Morris

May 4–6
Members Workshop
Sunset Center, Carmel
Faculty: James Alinder, Ruth-Marion
Baruch, Robert Byers, Martha Pearson
Casanave, David Featherstone, Susan
Friedman, Henry Gilpin, Pirkle Jones,
John Sexton, Al Weber

July 10–15
Asilomar Master Classes
Asilomar Conference Center, Pacific
Grove
Peter Bunnell: Historical and Theoreti-
cal Perspectives on Twentieth Century
Photography. Don Owens: Photo-
graphic Publishing. Robert Routh:
The Teaching of Photography. Jack
Welpott: Large Format Photography—
Contemporary Approaches to
Landscape.

August 10–12
Members Workshop
Sunset Center, Carmel
Faculty: James Alinder, Russell Ander-
son, Morley Baer, Lawrie Brown, Rob-
ert Byers, Martha Pearson Casanave,
David Featherstone, Susan Friedman,
Tom Millea, Arthur Ollman, Fred
Scheel, John Sexton, Lou Stoumen

1980

March 30–April 3
Easter Workshop
Sunset Center, Carmel
Faculty: Ansel Adams, Marsha Burns,
Michael Burns, Judith Golden, Rich-
ard Misrach, Olivia Parker

July 15–20
Asilomar Workshop
Asilomar Conference Center, Pacific
Grove
Faculty: Ruth Bernhard, Jo Ann Cal-
lis, Henry Gilpin, Bill Owens, Todd
Walker

August 15–17
Members Workshop
Sunset Center, Carmel
Faculty: Ruth-Marion Baruch, Edna
Bullock, Robert Byers, Martha Pear-

son Casanave, Joe Deal, Roy
DeCarava, Mary Lloyd Estrin, Bonnie
Ford, David Gardner, Richard Garrod,
Henry Gilpin, Wanda Hammerbeck,
Pirkle Jones, Greg MacGregor, Tom
Millea, Ted Orland, Peter Palmquist,
Fred Scheel, John Sexton, Lou
Stoumen

1981

April 12–16
Easter Workshop
Sunset Center, Carmel
Faculty: Linda Connor, Wanda Ham-
merbeck, Ted Orland, John Pfahl,
John Sexton

May 15–17
Members Workshop
Asilomar Conference Center, Pacific
Grove
Faculty: Lawrie Brown, Martha Pear-
son Casanave, Robert Dawson, Joe
Deal, James Doukas, Susan Friedman,
Jack Fulton, William Giles, Henry Gil-
pin, Mike Mandel, Kenda North,
Leland Rice, John Sexton, Linda
Troeller

July 12–17
Asilomar Master Classes
Asilomar Conference Center, Pacific
Grove
A. D. Coleman: Photographic
Criticism.
Judy Dater: Nudes, Portraits and Self-
Portraits.
William Jenkins: Collecting and
Exhibiting Photographs, A Curatorial
View.
Beaumont Newhall: On the History of
Photography.
The f/64 Tradition: Ansel Adams, Rus-
sell Anderson, Morley Baer, Susan
Ehrens, John Sexton, Brett Weston,
Charis Wilson

August 14–16
Members Workshop
Sunset Center, Carmel
Faculty: Morley Baer, Robert Byers,
Lisa Cremin, Greg Delory, Claudette
Dibert, David Gardner, Richard Gar-
rod, Wanda Hammerbeck, Ted
Orland, Alan Ross, Fred Scheel, Diana
Schoenfeld, Clinton Smith, Lou Stou-
men, Patricia White, Marion Post
Wolcott

September 30–October 4
Fall Landscape Workshop
Sunset Center, Carmel
Faculty: Lucien Clergue, Jack Sal, Gail
Skoff, Michael A. Smith, Don Worth

October 10
The Figure in Photography
Sunset Center, Carmel
Faculty: Marsha Burns

October 10
Architectural Photography Workshop
Sunset Center, Carmel
Faculty: Michael Burns

1982
June 17–20
Los Angeles Workshop
Golden West College, Huntington
Beach
Marsha Burns: The Figure in
Photography.
James Doukas: The Dye Transfer
Process.
John Sexton: The Fine Print.
John Upton: Teaching Photography.

July 11–16
Asilomar Master Classes
Asilomar Conference Center, Pacific
Grove
Peter Bunnell: Masters of Twentieth
Century Photography, Historical and
Theoretical Perspectives.
Andy Grundberg: Criticism Work-
shop, Understanding Photographs
through Critical Thinking.
Morley Baer: Architectural and Land-
scape Photography.
Bruce Davidson: Personal Concerns in
Photography.

August 1–7
The Ansel Adams Workshop
Robert Louis Stevenson School, Peb-
ble Beach
Faculty: Ansel Adams, Ruth Bern-
hard, Henry Gilpin, Mary Ellen Mark,
Joel Meyerowitz, John Sexton

August 8–14
The Ansel Adams Workshop
Robert Louis Stevenson School, Peb-
ble Beach
Faculty: Ansel Adams, Roy DeCarava,
Arthur Ollman, Olivia Parker, John
Sexton, Don Worth

August 27–29
Members Workshop
Sunset Center, Carmel

Faculty: Peter A. Andersen, Bruce
Barnbaum, Morrie Camhi, Lisa
Cremin, Ellen Manchester, Patrick
Nagatani, Alan Ross, John Sexton,
Lou Stoumen, Laura Volkerding, Jack
Welpott, Huntington Witherill, Jerry
Takigawa

October 14–18
Fall Landscape Workshop
Sunset Center, Carmel
Faculty: Ansel Adams, Linda Connor,
John Craig, Robert Dawson, Frank
Gohlke, Wanda Hammerbeck, Ellen
Manchester, Jerry Uelsmann

1983
April 13–17
The Photograph as Document
Hidden Valley Institute, Carmel Valley
Faculty: Louis Carlos Bernal, Morrie
Camhi, Bill Jay, Danny Lyon, Mary
Ellen Mark, Burk Uzzle

June 12–16
Making a Photographic Book: A Work-
shop on Self-Publishing
Hidden Valley Institute, Carmel Valley
Faculty: Peter A. Andersen, Nicholas
Callaway, David Gardner, Ralph Gib-
son, Katy Homans, Mike Mandel,
Floyd Yearout

June 19–24
Photography on the Monterey Penin-
sula: The $f/64$ Tradition
Asilomar Conference Center, Pacific
Grove
Faculty: Morley Baer, Robert Dawson,
Susan Ehrens, Henry Gilpin, Beau-
mont Newhall, John Sexton, Willard
Van Dyke, Charis Wilson

July 1–30
Photography in Paris, co-sponsored
with the Parsons School of Design, the
New School for Social Research and
the International Center of Photo-
graphy
Paris, France
Faculty: Benedict J. Fernandez, Claire
Peeps, Lee Wexler

July 22–24
Members Workshop
Hidden Valley Institute, Carmel Valley
Faculty: Peter A. Andersen, Robert
Byers, Lisa Cremin, James Doukas,
Susan Ehrens, David Featherstone,
Richard Garrod, Gary Goldberg,
Wanda Hammerbeck, Goodwin Hard-

ing, Fred Scheel, John Sexton, Rodney
Stuart, Huntington Witherill

July 31–August 6
The Ansel Adams Workshop
Robert Louis Stevenson School, Peb-
ble Beach
Faculty: Ansel Adams, Barbara Mor-
gan, Wright Morris, Olivia Parker,
John Sexton, Don Worth

August 8–14
The Ansel Adams Workshop
Robert Louis Stevenson School, Peb-
ble Beach
Faculty: Ansel Adams, Ruth Bern-
hard, Lucien Clergue, Eugene Rich-
ards, John Sexton, Jerry Uelsmann

October 5–9
Fall Landscape Workshop
Hidden Valley Institute, Carmel Valley
Faculty: Ansel Adams, Bruce Barn-
baum, Linda Connor, Jay Dusard,
Philip Hyde, Richard Misrach

1984
April 26–29
Exploring Photographic Processes
Hidden Valley Institute, Carmel Valley
Faculty: James Doukas, Tom Millea,
John Sexton, Melanie Walker

May 23–27
The Photograph as Document
Hidden Valley Institute, Carmel Valley
Faculty: Brian Lanker, John Loen-
gard, Mary Ellen Mark, Matthew
Nathans, Eugene Richards

June 22–24
Professionalism in Photography
Asilomar Conference Center, Pacific
Grove
Faculty: Peter A. Andersen, Morley
Baer, David Featherstone, Andy
Ostheimer, Susan Rankaitis, Roger
Ressmeyer, Alan Ross, John Sexton,
Dale Stulz

June 24–28
The Black and White Print
Asilomar Conference Center, Pacific
Grove
Faculty: Morley Baer, Jay Dusard,
Henry Gilpin, Chris Rainier, John Sex-
ton, Huntington Witherill

July 1–30
Photography in Paris, co-sponsored
with the Parsons School of Design
Paris, France

Faculty: Benedict J. Fernandez, Nancy Lloyd, Lee Wexler

July 16–19
Photography Today: Vision and Expression
Hidden Valley Institute, Carmel Valley
Faculty: Eileen Cowin, Robert Cumming, Robert Heinecken, Joyce Neimanas, Olivia Parker

July 20–22
Members Workshop
Hidden Valley Institute, Carmel Valley
Faculty: Peter A. Andersen, Robert Byers, Martha Pearson Casanave, David Featherstone, Susan Felter, Jeffrey Fraenkel, Richard Garrod, Michael Kenna, Erik Lauritzen, Ellen Manchester, Ted Orland, Olivia Parker, Fred Scheel, Lou Stoumen, Brian Taylor

August 4–10
The Ansel Adams Workshop
Robert Louis Stevenson School, Pebble Beach
Faculty: Ansel Adams, Ruth Bernhard, Paul Caponigro, Robert Dawson, Wanda Hammerbeck, Richard Misrach, John Sexton

August 12–18
The Ansel Adams Workshop
Robert Louis Stevenson School, Pebble Beach
Faculty: Ansel Adams, Judy Dater, Roy DeCarava, Tamarra Kaida, Norman Locks, John Sexton, Jerry Uelsmann

September 12–16
Fall Landscape Workshop
Hidden Valley Institute, Carmel Valley
Faculty: William Christenberry, William Clift, Linda Connor, Charles Roitz, Gail Skoff, Don Worth

November 3–20
The Unknown Land: Photographing in China
The People's Republic of China
Faculty: John Sexton

1985
May 8–12
The Documentary Photograph
Hidden Valley Institute, Carmel Valley
Faculty: Larry Clark, Jim Hughes, Mary Ellen Mark, Harry Mattison, Michael O'Brien

May 22–26
Publishing in Photography
Hidden Valley Institute, Carmel Valley
Faculty: Janet Swan Bush, Eleanor Caponigro, Monica Cipnic, David Featherstone, David Gardner, Carole Kismaric

June 5–9
The Fine Print
Asilomar Conference Center, Pacific Grove
Faculty: Morley Baer, Alan Ross, John Sexton, Jack Welpott, Huntington Witherill

July 5–7
Members Workshop
Asilomar Conference Center, Pacific Grove
Faculty: Ruth Bernhard, Robert Byers, Martha Pearson Casanave, Van Deren Coke, Robert Dawson, Richard Garrod, Henry Gilpin, Stephen Johnson, Erik Lauritzen, Patrick Nagatani, Ted Orland, Philipp Scholz Rittermann, Fred Scheel, Lou Stoumen, Melanie Walker

July 24–28
Facing the Camera: The Photographic Portrait
Hidden Valley Institute, Carmel Valley
Faculty: Bill Burke, Jay Dusard, Judith Golden, Annie Leibovitz, Arnold Newman

August 11–16
The Ansel Adams Workshop
Robert Louis Stevenson School, Pebble Beach
Faculty: Marie Cosindas, Duane Michals, Chris Rainier, John Sexton, Jerry Uelsmann

October 9–13
Fall Landscape Workshop
Hidden Valley Institute, Carmel Valley
Faculty: Linda Connor, Frank Gohlke, Mark Klett, Richard Misrach

1986
April
The Unknown Land: Photographing in China
The People's Republic of China
Faculty: John Sexton

June 8–12
The Black and White Print
Asilomar Conference Center, Pacific

Grove
Faculty: Morley Baer, Henry Gilpin, Michael Kenna, Huntington Witherill

June 18–22
The Photograph as Document
Hidden Valley Institute, Carmel Valley
Faculty: Lee Friedlander, Mary Ellen Mark, Eli Reed, Eugene Richards

July 11–13
Members Workshop
Hidden Valley Institute, Carmel Valley
Faculty: Henry Brimmer, Marsha Burns, Michael Burns, Morrie Cahmi, Lewis deSoto, Jay Dusard, Tim Jensen, Tom Millea, Paul Raedeke, Sam Samore, Jerry Takigawa, Brian Taylor, Catherine Wagner, Huntington Witherill

July 16–20
The Photographic Portrait
Hidden Valley Institute, Carmel Valley
Faculty: Marie Cosindas, Jim Goldberg, Gregory Heisler, Yousuf Karsh

August 2–6
The Ansel Adams Workshop
Robert Louis Stevenson School, Pebble Beach
Faculty: Mary Street Alinder, Ruth Bernhard, Arnold Newman, Alan Ross, John Sexton

August 13–17
New Directions in Photography
Robert Louis Stevenson School, Pebble Beach
Faculty: Jo Ann Callis, Barbara Kruger, William Wegman, Joel-Peter Witkin

1987
April 14–May 6
India with Mary Ellen Mark
India, Nepal, Kashmir, Thailand
Faculty: Mary Ellen Mark

June 7–11
The Photograph as Document
Hidden Valley Institute, Carmel Valley
Faculty: Richard Clarkson, Bruce Davidson, Anne Noggle, Gilles Peress, Sylvia Plachy

June 17–21
Light Explorations: Photographic Printing Alternatives
Hidden Valley Institute, Carmel Valley, and Hartnell College, Salinas

94

Faculty: Jerry Burchfield, Bea Nettles, Kenda North, Sheila Pinkel

July 10–12
Members Workshop
Asilomar Conference Center, Pacific Grove
Faculty: Ruth Bernhard, Lawrie Brown, Robert Byers, Robert Dawson, Richard Garrod, Sylvia Impert, Chris Johnson, Ellen Manchester, Frederick Mitchell, Margaretta Mitchell, Fred Scheel, Jack Welpott, Huntington Witherill

July 22–26
The Artist as Commercial Photographer
Hidden Valley Institute, Carmel Valley
Faculty: Sandi Fellman, Len Jenschel, Duane Michals, Victor Schrager

August 2–7
Imaging in the Eighties
Cornish College of the Arts, Seattle, Washington
Faculty: Paul Berger, Marsha Burns, Michael Burns, Lewis deSoto, Gary Hill, Barbara Hitchcock

August 11–16
The Ansel Adams Workshop
Robert Louis Stevenson School, Pebble Beach
Faculty: Morley Baer, Olivia Parker, Chris Rainier, John Sexton, Don Worth

GRANTS AND AWARDS

Ferguson Grant

Established in 1972 by Julia Siebel, of Los Altos, California, in memory of her father, W. D. Ferguson. The Ferguson Grant is awarded to an emerging photographer who has demonstrated excellence in and commitment to the field of creative photography.

1972 Anthony Hernandez
Jurors: Wynn Bullock, Robert Byers, Judy Dater, Richard Garrod, Jack Welpott

1973 Joseph Jachna
Jurors: Morley Baer, Robert Heinecken, William Webb

1974 Ken Graves
Jurors: James Alinder, Steve Crouch, Ted Orland

1975 Sally Mann
Jurors: Dave Bohn, Steve Crouch, Roger Minnick

1976 Richard Misrach
Jurors: Ralph Putzker, Alan Ross, Peter Hunt Thompson

1977 Meridel Rubenstein
Jurors: Ansel Adams, Judy Dater, Leland Rice

1978 Jo Ann Callis
Juror: Anne Noggle

1979 David Maclay
Juror: Peter Bunnell

1980 Mark Klett
Juror: Joe Deal

1981 Susan Felter
Juror: Linda Connor

1982 Lawrence McFarland
Juror: Anita Mozley

1983 Tamarra Kaida
Juror: Mary Ellen Mark

1984 Catherine Wagner
Juror: Susan Rankaitis

1985 Linda Robbennolt
Juror: William Jenkins

1986 Holly Roberts
Juror: Jonathan Green

1987 Peter Reiss
Juror: Jo Ann Callis

Ruttenberg Fellowship

Established in 1982 through a grant from the Ruttenberg Arts Foundation of Chicago, headed by attorney David C. Ruttenberg. The Ruttenberg Fellowship is awarded to a photographer who is establishing a record of excellence in the field and who is involved in a project in need of support.

1982 Tom Millea
Juror: Richard Koshalek

1983 Jim Goldberg
Juror: Olivia Parker

1984 Robert Dawson
Juror: Don Worth

1985 Barbara Bosworth
Juror: Robbert Flick

1986 Derrill Bazzy
Juror: Ruth Bernhard

Peer Awards in Creative Photography

Created by the Trustees of The Friends of Photography in 1980, these awards are presented to individuals with records of outstanding contribution to the field. Recipients are selected through a polling of a group of some 275 peers that represents a cross-section of the photographic world and includes photographers, critics, curators, historians, teachers and others.

Distinguished Career in Photography

Given to a senior figure who has demonstrated through a lifetime of work the highest standards of achievement in photography.

1980 Harry Callahan

1981 Aaron Siskind

1982 Frederick Sommer

1983 Berenice Abbott

1984 André Kertész

1985 Beaumont Newhall

1986 Robert Frank

Photographer of the Year

Intended as a "mid-career" award to recognize excellence in photography and to encourage further advancement.

1980 Lee Friedlander

1981 Joel Meyerowitz

1982 Robert Adams

1983 Paul Caponigro

1984 Jerry Uelsmann

1985 Robert Heinecken

1986 Linda Connor